Inside the Tower

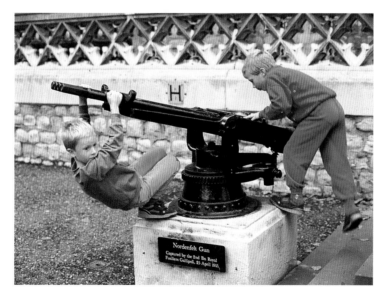

Nordenfelt Gun
Captured by the 2nd Bn Royal
Fusiliers Gallipoli, 25 April 1915

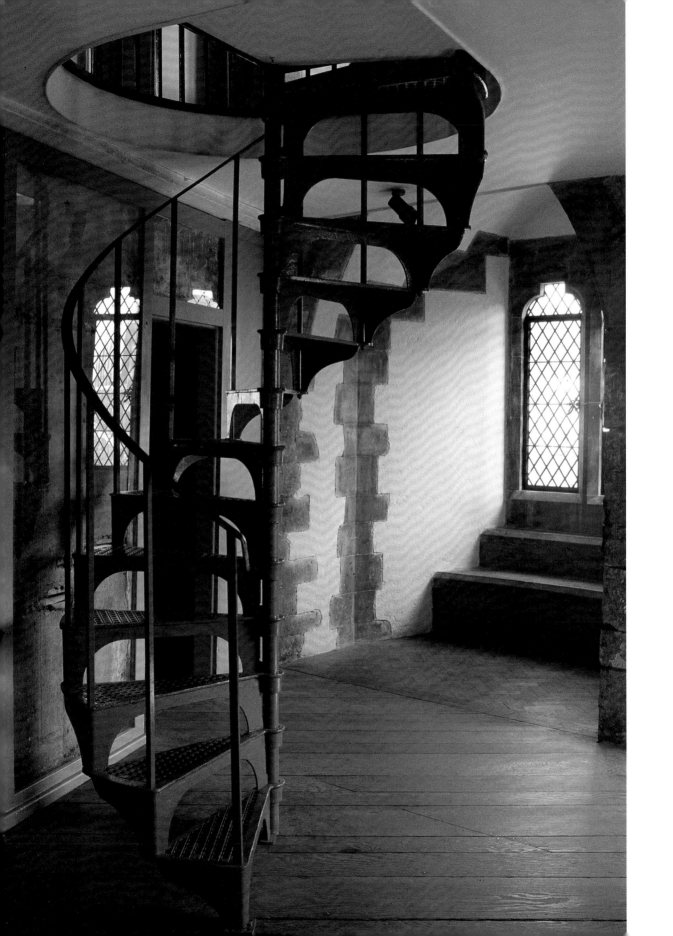

Inside the Tower

The Alternative Guide

James Bartholomew

with additional text by Julia MacKenzie

The Herbert Press

in association with HM Tower of London

First published in Great Britain 1990 by
The Herbert Press Ltd, 46 Northchurch Road, London N1 4EJ
in association with HM Tower of London

Designed by Pauline Harrison
Set in Sabon
Printed and bound in Great Britain by Butler & Tanner Ltd,
Frome, Somerset

ISBN 1-871569-21-4

Frontispiece: Staircase, Martin Tower

Front Cover illustration: Yeoman Warder Hauxwell
in sentry box
Back Cover illustration: The Tower of London
viewed from the south bank of the Thames

Other Herbert Press books
by James Bartholomew:

THE MAGIC OF KEW
THE CITY OF LONDON

Contents

This book is dedicated with
much love to my parents

Introduction

Major-General (retd) Christopher Tyler, CB
Resident Governor

In any guide book, especially one which aims to cover such a long period of our history, it is always a problem of what aspects to include and how to describe them. It is also difficult to catch the true atmosphere of the Tower; too many people concentrate on its role as a prison, forgetting that for 700 of its 900 years it was *not*, primarily, a prison.

James Bartholomew has tackled these problems with two valuable weapons – his camera and his boots! The former he has used with a successful mixture of art and science to produce a whole range of excellent shots; if pictures are worth a thousand words, the reader of this book is getting a thesis. The other weapon, his boots, have become a familar sight in the Tower; James has walked many miles all over our eighteen acres, talking to many of us who live and work here, exploring the remote corners and getting the 'feel' of this living place, Her Majesty's Royal Palace and Fortress, The Tower of London.

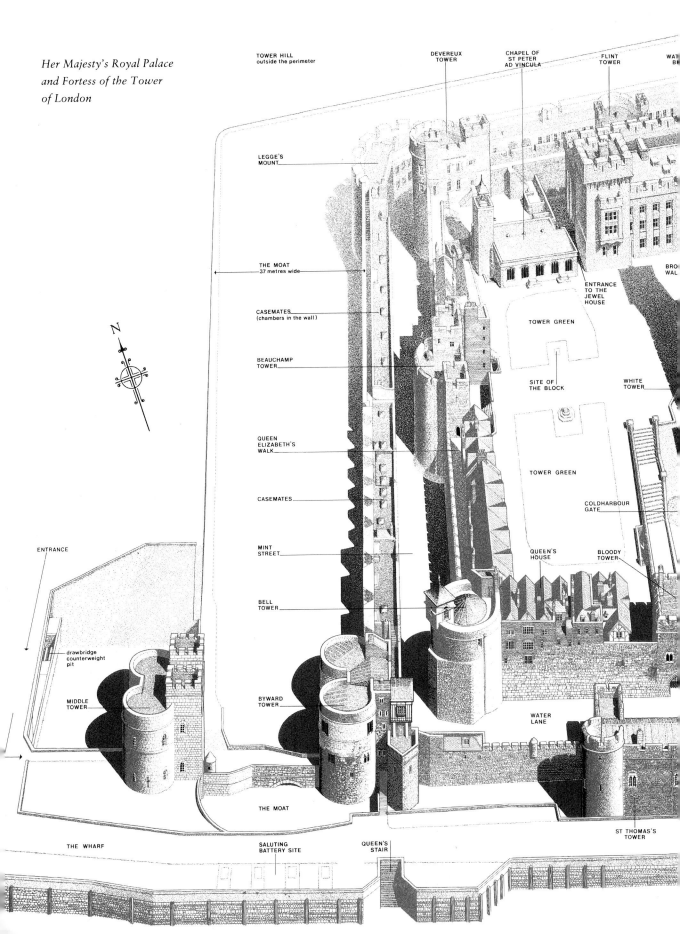

Her Majesty's Royal Palace
and Fortess of the Tower
of London

TOWER HILL
outside the perimeter

DEVEREUX
TOWER

CHAPEL OF
ST PETER
AD VINCULA

FLINT
TOWER

WAT
B

LEGGE'S
MOUNT

BRO
WAL

THE MOAT
37 metres wide

ENTRANCE
TO THE
JEWEL
HOUSE

CASEMATES
(chambers in the wall)

TOWER GREEN

BEAUCHAMP
TOWER

SITE OF
THE BLOCK

WHITE
TOWER

QUEEN
ELIZABETH'S
WALK

TOWER GREEN

CASEMATES

COLDHARBOUR
GATE

MINT
STREET

QUEEN'S
HOUSE

BLOODY
TOWER

ENTRANCE

BELL
TOWER

drawbridge
counterweight
pit

MIDDLE
TOWER

BYWARD
TOWER

WATER
LANE

THE MOAT

ST THOMAS'S
TOWER

THE WHARF

SALUTING
BATTERY SITE

QUEEN'S
STAIR

N

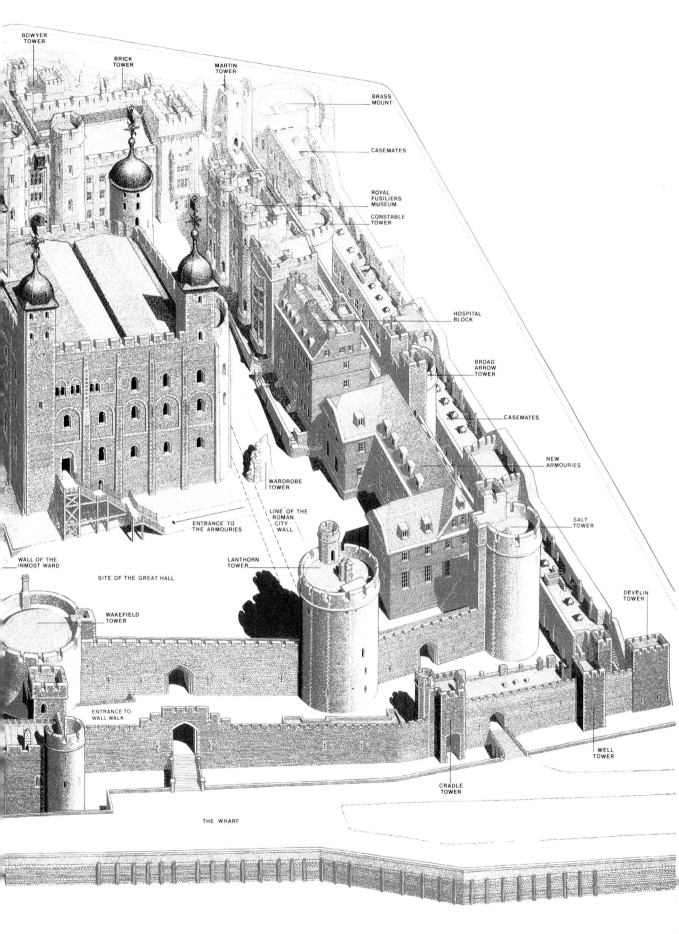

BOWYER
TOWER

BRICK
TOWER

MARTIN
TOWER

BRASS
MOUNT

CASEMATES

ROYAL
FUSILIERS
MUSEUM

CONSTABLE
TOWER

HOSPITAL
BLOCK

BROAD
ARROW
TOWER

CASEMATES

NEW
ARMOURIES

ENTRANCE TO
THE ARMOURIES

WARDROBE
TOWER

LINE OF THE
ROMAN
CITY
WALL

SALT
TOWER

WALL OF THE
INMOST WARD

SITE OF THE GREAT HALL

LANTHORN
TOWER

DEVELIN
TOWER

WAKEFIELD
TOWER

ENTRANCE TO
WALL WALK

WELL
TOWER

CRADLE
TOWER

THE WHARF

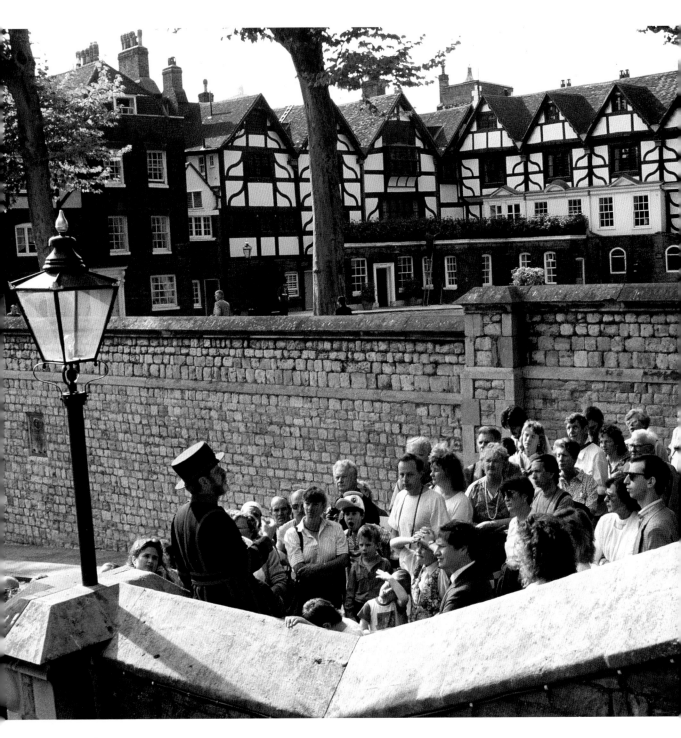

The Yeoman Warder Guided Tour

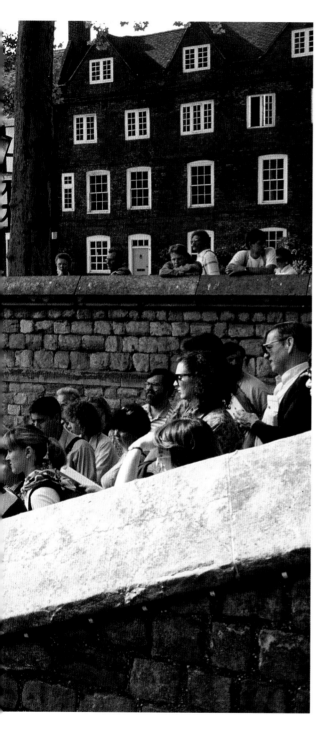

There are many different ways to learn about the Tower of London. Much information is available from the numerous books on sale at the Tower shops, but obviously it is best to visit the Tower in person. Visitors come in groups, as members of guided parties, with their families, or on their own. Many tours are available, most of which have knowledgeable guides, and the City of London 'Blue Badge' guides are excellent.

However, an informative and entertaining tour is provided on the spot by a Yeoman Warder, at no extra charge, and is wholeheartedly recommended. It is provided up to twelve times a day, weather permitting, and starts from the causeway between the Middle and Byward Towers. The Yeoman Warders are all ex-NCOs (non-commissioned officers) who have a natural authority when dealing with large numbers of people, and voices trained to project across a parade ground. A typical tour is described below.

We are welcomed to 'Her Majesty's Royal Palace and Fortress of the Tower of London', the oldest inhabited palace in the world, and told that the original Tower was the White Tower, which took twenty years to complete (1078–97). We are reminded that William the Conqueror maintains his status as leader of the last armed force suc-

A guided tour, with the Queen's House beyond

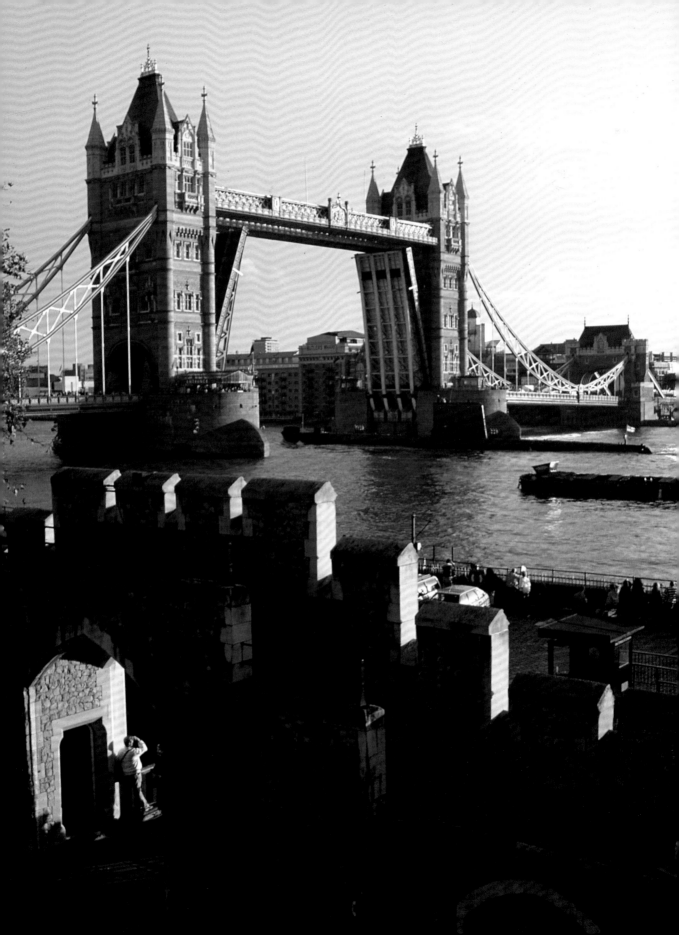

cessfully to invade England. Our Yeoman guide then describes how successive monarchs continued to enlarge and enhance the defences by building the inner and outer walls: the inner wall having thirteen towers, the outer one six, all on the river side. (Don't be tricked by the question 'How many complete towers are there?'. It is not nineteen, but twenty because you have to include the White Tower.) It is mentioned that owing to a design fault, Longchamp's moat of the late twelfth century was dug deeper than the Thames, and that all the waste and filth from the Tower and surrounding streets sank to the bottom, rather than being flushed by the tidal waters of the Thames. Since this turned the moat into the largest stagnant cesspool in Europe, it was by far the most effective line of defence!

As well as being a royal palace, we are told that the Tower was used for many other purposes over its long history: Royal Observatory, storage facility for arms, stores and public records, Mint, menagerie, home of the Crown Jewels and State Regalia, and perhaps its most infamous use, that of state prison for political and religious prisoners.

We are asked to notice the large, former Port of London Authority building on Tower Hill, in front of which, in Trinity Gardens, lies a plaque marking the public execution site. In spite of the Tower's reputation for death and beheadings, which is reinforced by our guide's graphic account of a typical public execution, we are surprised to learn that, in total, only 112 people were executed on Tower Hill, starting with Simon of Sudbury, Archbishop of Canterbury, in 1381, and ending with Lord Lovat in 1747.

Details of all the buildings are given as we

pass inside: Middle Tower, Byward Tower (which together formed part of the main land entrance to the Tower), then through to the outer ward (between the inner and outer defence walls), where the Bell Tower is described in detail, having contained such famous prisoners as Sir Thomas More and John Fisher. Also imprisoned here were Princess Elizabeth (later Queen Elizabeth) and the Duke of Monmouth, who fought the last full battle on English soil, at Sedgemoor. All the gory details of the Duke's execution are related (it took five blows of the axe to decapitate him).

Moving on to an area beneath the balcony at the back of the Queen's House, we are told of the examination of Guy Fawkes in the Council Chamber on the second floor, and the daring escape of Lord Nithsdale in 1716 (see p. 123). After that we move along to the Traitors' Gate (for the benefit of American visitors the guide will point out that this is the Watergate), and listen as sixteen well-known people are listed as having arrived at the Tower through this entrance, most of whom were on their way to their deaths.

Turning around, we see the Bloody Tower, home for many years for Sir Walter Ralegh, and possibly the two young 'Princes in the Tower', to name but a few of the prisoners held there. The Wakefield Tower to the right is also mentioned, as the scene of the murder of Henry VI. We then pass underneath the only working portcullis in the Tower, which requires twelve men to lift it, although the Yeoman Warder reminds us of the Errol Flynn film *Robin Hood*, in which he held up the portcullis with one hand!

Once in the inner ward, literally in the shadow of the White Tower, we are given many interesting facts about the building, including the fact that the royal coat of arms on the weathervanes denote that it is still a royal palace. This part of the tour is conducted with the same fluent patter that is

Submarine passing under Tower Bridge

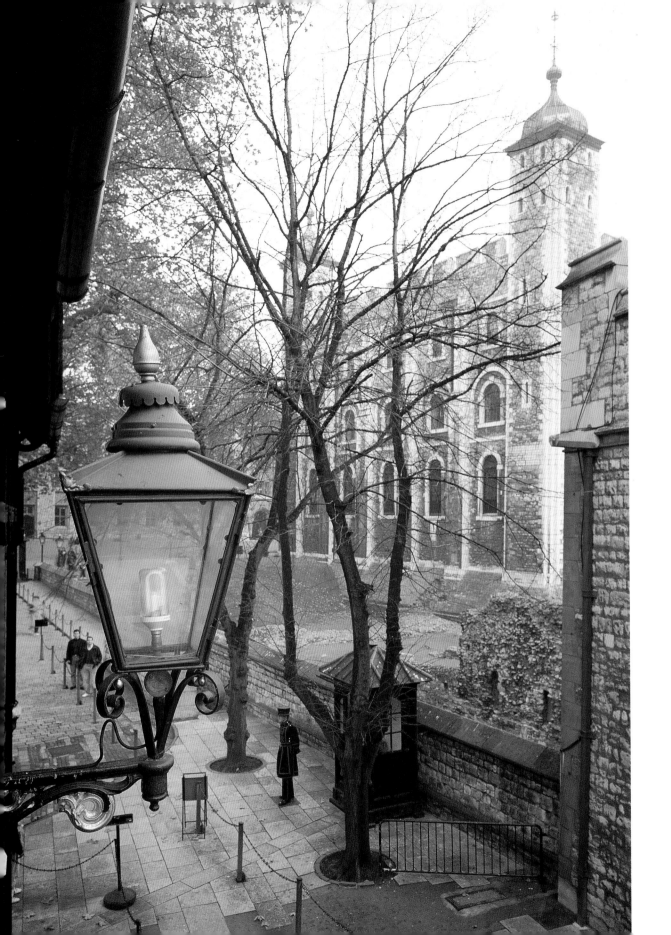

View from the Bloody Tower steps

spoken all along, and concludes: 'Right, ladies and gentlemen, we have seen where kings and queens lived, follow me to Tower Green and we shall see where some of them died.'

At Tower Green the layout of this part of the inner ward is described: the entrance to the Bloody Tower, Queen's House, Beauchamp Tower (pronounced Beecham), the Chaplain and Doctor's residences, and the Chapel of St Peter ad Vincula. Then we are given details of some of the six unfortunates who were despatched upon the

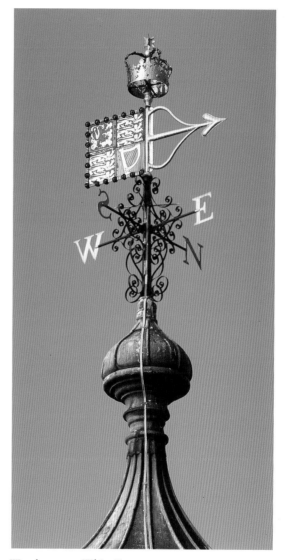

Weather vane, White Tower

Yeoman Warder Coyle leading a tour, Tower Green

private scaffold: Anne Boleyn, Margaret Pole, Countess of Salisbury, Katherine Howard, Lady Jane Grey, Jane, Viscountess Rochford, and Robert Devereux, Earl of Essex, victim the last time the axe was to fall on this spot, in 1601.

Finally we are invited to enter the Chapel of St Peter ad Vincula having been reminded that it is a Chapel Royal. The chapel is a fitting place to end the tour. Taking a seat for a well-earned rest we can listen while our guide passes on more impressive snippets of historical information: that there has been a chapel roughly on this spot since the year 1110, originally just outside the Tower walls; that Queen Victoria is said to have visited the chapel and tripped on the uneven flagstones, prompting her instruction that the chapel be restored to its Tudor glory. Among other renovations, the beautiful Spanish chestnut roof beams were revealed and the floor relaid. This involved exhuming and reburying some 1500 bodies found as little as two feet below the surface, the most important being reburied beneath the altar (see p. 27). The chapel visit concludes the tour and we are then free to wander around the Tower at our leisure.

It will be clear that the Yeoman Warder has an arduous and demanding job at the Tower, with few tea breaks and a lot of standing around. As light relief in dealing with the questions repeatedly asked by curious visitors, many Yeoman Warders make a point of developing their own particular brand of wit, revealing a style of humour that for the most part is drier than the palest of English sherries and able to carry a gentle sting when the occasion dictates, although without offence. The average Yeoman will have had several years experience and millions of inquiring tourists on whom to try his skill, and will be able to hold the attention of up to 350 people on one of his tours, making the walls ring with grateful laughter.

The Chapel of St Peter ad Vincula (interior)

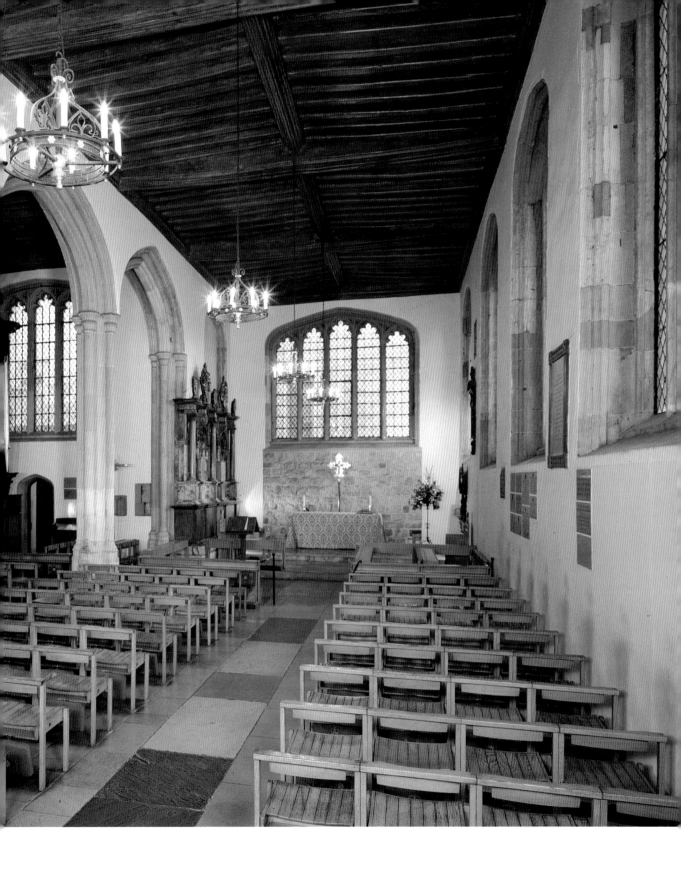

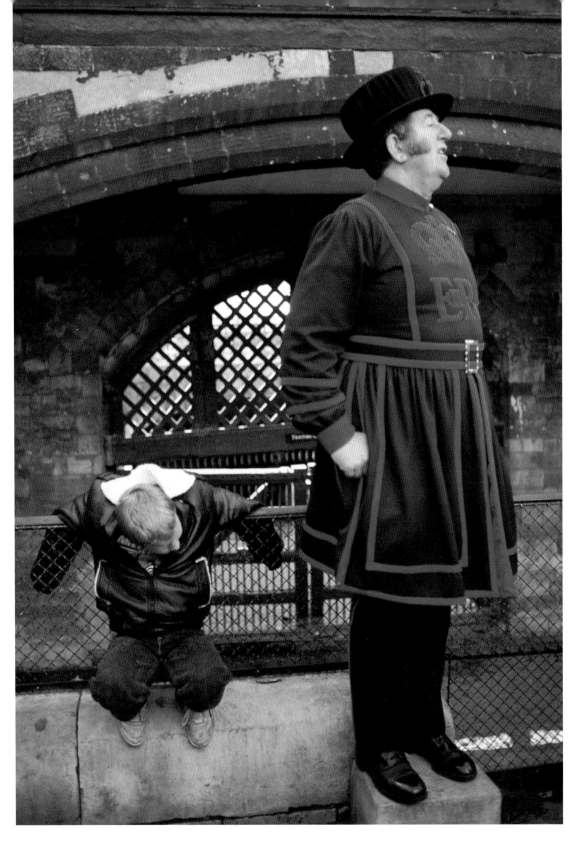

Yeoman Warder Canderton leading a tour

The warders have been asked some curious questions over the years, and witnessed some strange goings-on. There is, for example, a story of two elderly ladies, one of whom wanted to photograph her friend with a Yeoman Warder but was pointing the camera lens towards herself. The Yeoman was eventually able to persuade her that she was in fact taking a picture of her own right eye, and turned the camera round for her. As they walked away, he overheard her say to her companion, 'Maud, we'd better go back and do all those other pictures again: we've been doing it the wrong way!'

Another Yeoman Warder reported getting into a conversation with a plumber's mate working at the Tower and trying to explain to him the attractions of the building. The only response was, 'As far as I'm concerned, they should pull the whole lot down and make council houses ... but I'll tell you something: they must have been strong in them days, to wear all this armour and carry all them big swords ... And you know what? I reckon this place was a castle, when it was first built!' And Yeoman Warders frequently have to listen without flinching to unanswerable questions such as 'Did John Dudley carve his name on the wall before or after he was executed?'

Yeoman Warders are adept at giving witty answers to the most straightforward questions: when asked by a visitor if all the ravens were buried beneath the Ravens Memorial in the moat,

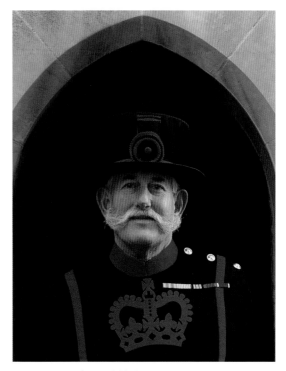

Yeoman Warder Hubble by the Salt Tower

a warder replied 'No, Madam, only the dead ones'. Another tourist, innocently asking where prisoners had their heads cut off, was told, 'usually just above the shoulders'.

In response to a warder's description of the Ceremony of the Keys as living history, one visitor queried the description as a contradiction in terms, *living* history. Not to be outdone, the warder quipped 'Yes, it is a contradiction in terms, like Military Intelligence'.

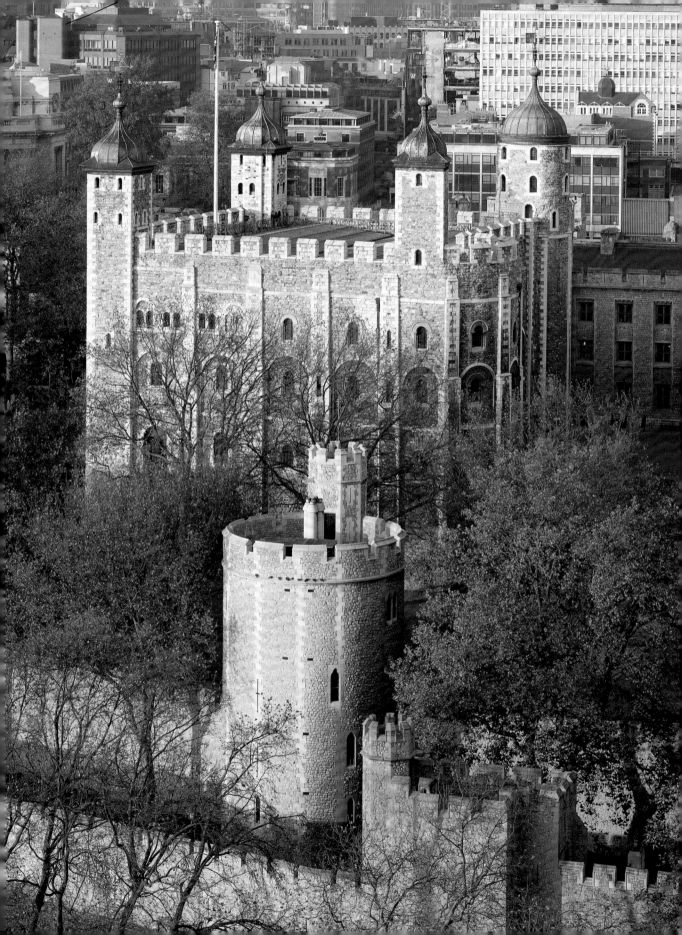

Twenty towers and other buildings

All buildings are listed alphabetically. The notes can be referred to when visitors are walking around the Tower grounds, or, if the name is not known, by looking at the illustrated map on pp. 8–9.

Beauchamp Tower

As part of Henry III's expansion of the castle perimeter a land gate was built on this site. It is reported, however, that on the night of 23 April 1240 (St George's Day) the gate collapsed, followed exactly a year later by part of the nearby curtain wall. On both occasions the ghost of Thomas à Becket (the Archbishop of Canterbury murdered in 1170, and a Constable of the Tower) was said to have been seen beating the ground with his crozier. The gate was replaced in 1281 by the present tower when Edward I created a new land entrance to the southwest.

Originally only two storeys high, the tower provided suitable accommodation for aristocratic prisoners and their retinue of servants. One such was Thomas de Beauchamp, Earl of Warwick, imprisoned there in 1397 for treason against Richard II, and after whom the tower is named.

Cradle, Lanthorn and White Towers
from Tower Bridge

Dudley Memorial, Beauchamp Tower

Boredom must have been a major factor in the prisoners' lives and this perhaps accounts for the inscriptions found here (and others brought here from elsewhere in the Tower), some eighty-seven in all. One of the finest is the Dudley memorial. John Dudley, Duke of Northumberland and his five sons were imprisoned in the Tower for the

attempted coup against Mary I in 1553, in which Lady Jane Grey reigned for nine days. The sons were kept in the Beauchamp Tower and one of them, Guildford Dudley, Jane's husband, may have been the carver of the word IANE, to be found near the large window overlooking the inner ward. More detailed information is available in *Inscriptions* by Sarah Barter.

Bell Tower

The oldest surviving tower apart from the White Tower, it was probably built by William Long-champ, Chancellor during the reign of Richard I (the Lionheart), as part of the expansion of the Tower beyond the Norman keep and bailey area. The curtain wall to the east of the Bell Tower was probably built at the same time. Both would have been right on the river.

The tower is unusual in having a polygonal base and circular upper storey – an indication that it was probably built in two stages. The arrow slits are well designed to deflect an enemy's arrows, as demonstrated recently when an expert bowman made several unsuccessful attempts to shoot an arrow in through one of the slits.

The tower was known by its present name from 1532, but the present bell and housing date from 1651. The bell was rung as an alarm and as a curfew – to tell the prisoners given the liberty of the Tower that it was time to return to their quarters. Today it is used to warn the public that the Tower is about to close.

In the sixteenth and seventeenth centuries the tower was used by some very important prisoners (one could say VIPs!). Maximum security could be maintained because the only access was through the Queen's House. Sir Thomas More, John Fisher, Bishop of Rochester, Princess Elizabeth, Arabella Stuart and the Duke of Monmouth

all spent time in this tower. More and Fisher were here concurrently – Fisher in the upper chamber, More in the lower.

Bloody Tower

This was originally a watergate, created in about 1220 when Henry III extended the castle perimeters, but became the gateway to the inner ward when Edward I reclaimed land from the river to make the outer ward (Water Lane) and built a new watergate (St Thomas's Tower). The first floor of the tower dates from the mid four-teenth century and provided palatial accom-modation – tiled floor, fireplace and window seats – but also reflected the defensive function of the tower with portcullises for the inner and outer gateway at either end of the apartment (the southern one remains to this day, though it dates from the sixteenth century). The vault in the passage below also dates from Edward III's reign; it was constructed by Robert Yevele in 1360–2.

The tower was originally called the Garden Tower because it was at the corner of the Queen's House garden, but sometime in the sixteenth century its name changed to the Bloody Tower because of its supposed association with the young 'Princes in the Tower', who disappeared in 1483 (see p. 114). The proximity of the tower to the Queen's House and the style of accomodation did make it a suitable place for noble prisoners, however. Its most famous resident was Sir Walter Ralegh, for whom a second floor was added in 1605–6, and today's visitor sees the tower fur-nished as it might have been in the period he lived here with his wife and children (his second son was baptised in the Chapel of St Peter in 1605). Ralegh spent thirteen years in this tower during which time he wrote his *History of the World* (see pp. 120–1). Other famous prisoners held here

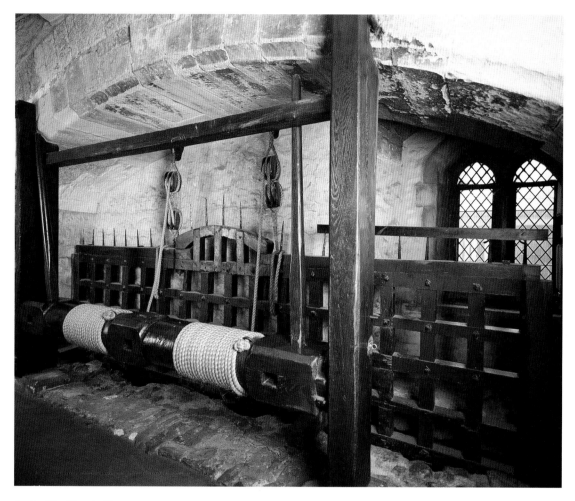

Portcullis, Bloody Tower

include Archbishop Laud, executed in 1645, and the Lord Chancellor, Judge Jeffreys of the 'Bloody Assizes', who died of drink here in 1689 before he could be executed.

Bowyer Tower

The tower stands on the site of the Roman city wall and was one of a series of towers erected by Henry III as part of a new outer wall for the Tower of London. A moat would originally have existed on its far side.

The name may be because the royal bow-maker, or bowyer, lived here. A later resident was George, Duke of Clarence, imprisoned for treason against his brother, Edward IV. He was found dead in this tower in 1478, supposedly drowned in a butt of malmsey wine.

23

The present tower is a nineteenth-century reconstruction since it was a stove flue in this tower that started the great fire of 1841.

Brass Mount

Partly altered over the years, this bastion in the northeast angle of the outer ward was an early addition to the curtain wall, but nevertheless probably dates from the reign of Edward I. The deployment of heavy brass cannons here during the seventeenth century explains the origins of its present name. Its military function continues to this day.

Brick Tower

Originally built in the mid thirteenth century as part of Henry III's new towered curtain wall, it was rebuilt in brick – hence its name – some time between 1510 and 1520, as the Master of Ordnance's residence. Later that century, Sir Walter Ralegh was briefly imprisoned here when he offended Queen Elizabeth for seducing, and secretly marrying, Elizabeth Throckmorton, one of her maids of honour.

The 1841 fire (see p. 124) at the Tower of London destroyed the Brick Tower and the present one is a Victorian reconstruction.

Broad Arrow Tower

Henry III's extension of the fortress east, beyond the old Roman city wall, involved the creation of a new curtain wall commanded by a series of towers, of which the Broad Arrow Tower was one. But the towers were designed for residential use as well as military, and the inscriptions show how this one served as a prison cell. One room has been furnished – complete with model of knight and dog (which is so authentic visitors have complained about the cruel practice of stuffing dogs! but the bone in front of him is real) – to show how it would have looked when occupied by Sir Simon Burley, Richard II's tutor, who took refuge in the Tower during the Peasant's Revolt (1381). Seven years later, in 1388, he was to be victim of the first official execution on Tower Hill.

The origin of the tower's name is not clear; it could be from the broad arrows which were part of a medieval bowman's ammunition, or from the traditional broad arrow mark designating government property.

Byward Tower

Edward I created a brilliantly engineered new land entrance, including a new moat, in the years 1275–81. Heavily fortified, any attackers would have to negotiate a drawbridge to the outer barbican or Lion Tower (since partly demolished and buried, but the counterweight pit for the drawbridge can still be seen from the path down to the Middle Tower), then via two more drawbridges separated by the Middle Tower with its two portcullises, they would reach the Byward Tower (if they were lucky!). There two more portcullises provided further protection; the western one, probably dating from the fifteenth century (and the oldest surviving device of its kind in the country), remains. The tower is the last defence before the outer ward and the fact that it was by the Warders Hall may be the origin of its name.

In the room (closed to the public) containing the winch for the portcullis, wall paintings dating from late in the reign of Richard II (1377–99) were discovered in 1953. They are the only medieval paintings which survive at the Tower and, although damaged by Tudor remodelling, show a Crucifixion scene and emblems of royal heraldry.

Arched window, Middle Tower

Arrow slit

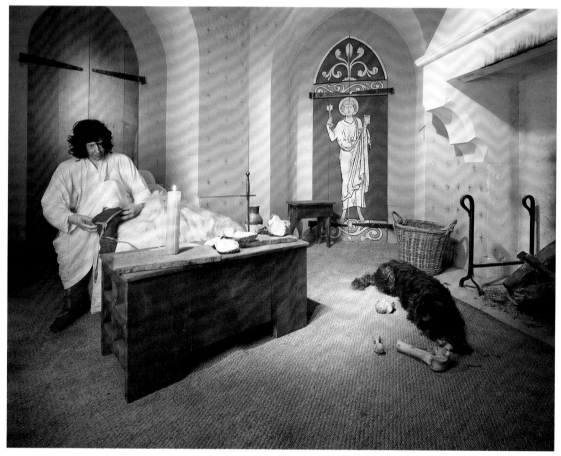

Knight's bedchamber, Broad Arrow Tower

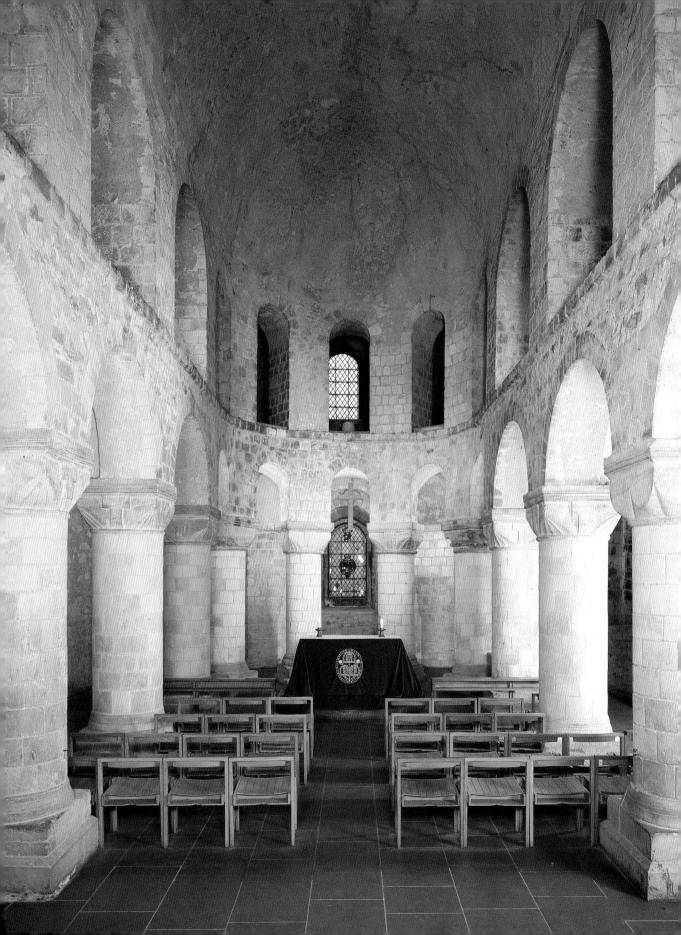

The Chief Yeoman Warder and Yeoman Gaoler have their offices in this tower on one side of the arch, and the main office for the Yeoman Body is on the other, so any wrongdoers in this area have to beware.

Casemates

These are houses built within the outer walls of the Tower of London during the nineteenth century, and which provide homes for the Yeoman Warders and their families. For this reason Mint Street is not open to the public.

A miniature rifle range in the northeast casemates was the execution site for eleven spies in World War I, and for one German spy in World War II.

Chapel of St John the Evangelist

One of the finest examples of early Norman architecture, the chapel today is much as it was when Gundulf, Bishop of Rochester built it. Constructed of Caen limestone as part of the White Tower, it rises through two floors with a triforium at the upper level and, rare for England, has a tunnel-vaulted nave. Also unusual is the apsidal projection which runs down through the crypt and sub-crypt to the base of the keep.

The chapel was used throughout the Middle Ages by the king and court when they were in residence at the Tower, and is particularly associated with the Order of the Bath whose knights would hold all-night vigils here prior to their investiture. By Charles II's reign, however, the Tower was so little used as a royal residence that the chapel became a store for state records. With

The Chapel of St John the Evangelist

their removal to the new Public Records Office in 1857, the chapel was restored to its original splendour. Services are now held here at Christmas, Easter and Whitsun. Prince Charles came here on his twenty-first birthday to receive Communion.

Chapel Royal of St Peter ad Vincula

Originally a parish church, this became the chapel for the inhabitants of the Tower after Henry III's new curtain wall brought it within the boundaries of the Tower in the mid thirteenth century. The dedication to St Peter in chains has long been thought apt for the last resting place of so many Tower prisoners, but the consecration obviously preceded this use, and probably took place on 1 August, the feast of St Peter ad Vincula, in 1110.

Destroyed by fire in 1512, the chapel was rebuilt and resited so the south wall of the previous building became the north wall of the new chapel, a fine example of early Tudor ecclesiastical architecture. Many of those who died in the Tower or perished on the scaffold were buried here, often with no marker. Identification was therefore difficult when the chapel floor was lifted and the bones exhumed as part of the chapel's restoration in 1876–7. Those remains found in the nave were reburied in the crypt, while those of people of distinction known to have been buried in the chancel – Anne Boleyn, Katherine Howard, Lady Jane Grey (who had literally kept their heads about them!) and the Dukes of Northumberland and Somerset among others – were replaced there beneath marble paving giving their names and armorial bearings. A tablet on the west wall of the chapel lists thirty-four 'remarkable persons' buried in the chapel in the period 1534–1747, and includes the three saints, Sir Thomas More, John Fisher, Bishop of Rochester and Philip Howard.

One of the oldest monuments in the chapel is the alabaster tomb-chest of Sir Richard Cholmondeley and his wife. He was Lieutenant of the Tower during the reign of Henry VIII but lost favour when he over-reacted to a riot between Londoners and Lombards by firing some of the Tower's artillery at the City, and was not buried here. When opened in 1876 during the Victorian restoration, the tomb revealed a Tudor font cut into four sections, thought to have been hidden there during the Commonwealth. It has been reassembled and stands by the west entrance.

The chapel became the garrison church in 1877 and only made a Chapel Royal (outside episcopal jurisdiction) in 1966. Today it serves as the parish church for the Tower community. Visitors on a Yeoman Warder tour and those who attend a religious service will see inside the chapel, but in the normal course of events they are not otherwise admitted.

Constable Tower

This is one of Henry III's curtain wall towers. The origin of the name is unclear as it is unlikely that any Constable of the Tower lived here. During the later Tudors and Stuarts it was pressed into service as prison accommodation. Rebuilt in the nineteenth century, the tower is now part of the wall walk and is the home of a Yeoman family.

Cradle Tower

This was built in the years 1348–55 in the outer wall of the fortress, to give the King (Edward III) a private water entrance to his apartments, located in this period in or by the Lanthorn Tower. The name possibly derives from an apron on which a boat could rest at low tide. Defence was provided by two portcullises.

Richard II, Edward's successor, made only limited improvements to the Tower, but they did include the extension of Tower Wharf east from St Thomas's Tower, cutting short the use of the Cradle Tower as a watergate. It was subsequently used to accommodate less important prisoners. The lower chamber may be visited and the story of the famous escape of two prisoners in 1597 is there recounted.

Develin Tower

Dating from the reign of Edward I but partly rebuilt in the seventeenth century and partly refaced in the nineteenth century, this is the furthest tower to the east, almost a promontory into the moat. It was a postern-tower with a road running through it, and a 1597 plan shows a causeway running from it across the moat to the Iron Gate (since demolished). The tower provided a good defensive view north along the outer wall to the Brass Mount. It is not open to the public.

Devereux Tower

Part of Henry III's extension to the castle in the mid thirteenth century, the Devereux Tower stands in the northwest corner of the inner ward, providing solid defence on the City side, the part of the fortress most prone to attack. Its name derives from Robert Devereux, Earl of Essex, fallen favourite of Elizabeth I, who was imprisoned here for two weeks prior to his execution on Tower Green in 1601, the last on that spot. The tower is now a Yeoman Warder residence.

The Chapel of St Peter ad Vincula

The Tower of London from northwest; Legge's Mount is the corner bastion in the outer wall (B. Ramamrutham)

Flint Tower

Part of Henry's extension of the Tower perimeter to the north, the present tower is largely a nineteenth-century recontruction. The origin of the name is not known, but is believed to derive from its being faced with flintstone.

Lanthorn Tower

Built in the 1220s by Henry III (1216–72) it formed, together with the contemporaneous Wakefield Tower, the southern projection to the inner bailey and abutted straight onto the river. Indeed, it gained its name from the lantern or flare which

was placed at night in the small turret on the roof as a marker for ships on the river.

Edward I's great expansion programme removed the Lanthorn Tower from its riverside position (see map p. 109) and during the reign of his grandson, Edward III (1327–77), the King's apartments were moved to or near the Lanthorn Tower. The tower was subsequently used to accommodate prisoners and, in the seventeenth century, the Master of Ordnance. A fire partly destroyed the tower in 1774 and the remains were demolished thereafter. The present one is a reconstruction by John Taylor in 1882–3. Public access through the tower is via the wall walk.

Exhibits include a model of the Tower in 1890 and a model wearing the state dress uniform of the Yeoman Warders.

Legge's Mount

Legge's Mount protects the northwest angle of the outer wall in the way the Brass Mount guards the northeast corner. Probably dating from the reign of Edward I, it was raised to its present height in 1683 to accommodate gun batteries, as part of Charles II's scheme to put ninety guns along the walls. Its name dates from the same period – George Legge, Lord Dartmouth, was appointed Constable of the Tower in 1684.

Martin Tower

This angle tower formed part of Henry III's new line of defences for the Tower of London. Inscriptions testify to its use as a prison, and it was here that the ninth Earl of Northumberland, the 'Wizard Earl', spent his years of confinement, albeit in considerable style, during the early seventeenth century (see p. 121). The less luxurious treatment given to some prisoners can be seen by today's visitor to this tower – a reconstruction of the rack, on view with other torture instruments. Evidence suggests that these were employed in the basement of the White Tower.

The Martin Tower housed the Crown Jewels from 1669 until 1841, when the Grand Storehouse fire nearly destroyed them (see p. 124). The tower still contains many features from the sixteenth to nineteenth centuries.

Middle Tower

The main entrance for Tower visitors today, the Middle Tower, as its name suggests, was pos-itioned between two others – the Lion Tower (no longer visible) and the Byward Tower, as part of Edward I's new land entrance to the fortress (see p. 106). The slots for two portcullises can be seen inside the archway. The royal arms above the arch are those of George I, king when the tower was partly re-faced with Portland stone.

New Armouries

Built in 1663-4 as a storehouse for small arms by the Board of Ordnance, this splendid brick building now houses the British Military Armoury section of the Royal Armouries.

During the early months of World War II it housed the Prisoner of War Collection Centre, through which almost 200 Naval and Luftwaffe captives passed before its subsequent move to Cockfosters.

Queen's House

A rebuilding by Henry VIII of an existing house, this timber-framed Tudor structure was originally called the Lieutenant's Lodgings, and today is the home of the Governor, the Lieutenant's successor as officer with local command of the Tower. Technically it is the sovereign's residence in the Tower, and since 1858 has been called the Queen's House, or King's House depending on the sovereign. Because it is a private home, the building is not open to the public.

Distinguished prisoners were lodged here and in the adjacent Bell Tower (access only via the Queen's House) under the watchful eye of the Lieutenant, who would entertain them to dinner in his quarters in the south wing. The prisoners themselves, Anne Boleyn and Katherine Howard among them, stayed in rooms in the west wing.

In the Council Chamber on the second floor of

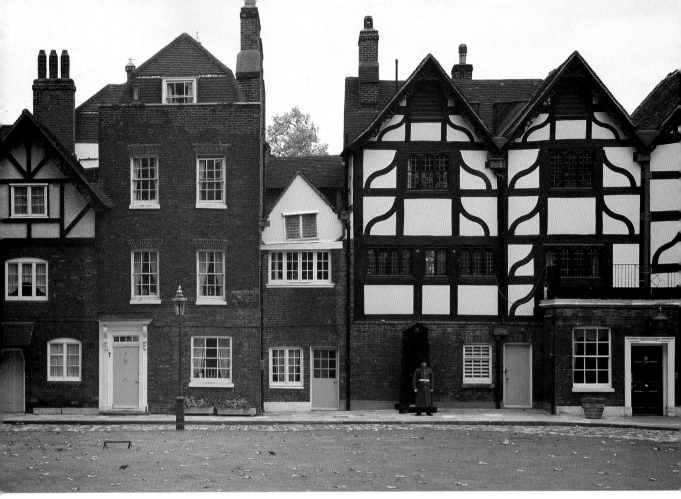

The Queen's House

the south wing Guy Fawkes was examined before and after his torture on the rack in the White Tower. He was eventually hanged, drawn and quartered in Palace Yard, Westminster, ironically so close to the target of his Gunpowder Plot.

The last state prisoner to stay in the Queen's House was Rudolf Hess, Deputy Führer of Nazi Germany, who was held here from 17–21 May 1941.

Royal Fusiliers Museum

The Royal Regiment of Fusiliers' connection with the Tower goes back to Monmouth's rebellion in 1685, when the regiment was raised, and posted to the Tower to protect the guns, by the Constable,

George Legge, Lord Dartmouth. It was the first regiment to be issued with an improved musket, a Fusil. In King James II's commission to Lord Dartmouth, he called the regiment 'Our Royal Regiment of Fusiliers', the name it bears today. Soon after formation the regiment adopted the shorter name 'The Royal Fusiliers' and in 1881 was granted the honour of the additional title 'City of London Regiment'.

The Protestant Duke of Monmouth, Charles II's illegitimate son, had landed in Dorset in an attempt to wrest the throne from his uncle, the Catholic King James II. He was defeated at Sedgemoor, imprisoned in the Bell Tower, and executed on Tower Hill. There is a story that his portrait which now hangs in the National Portrait

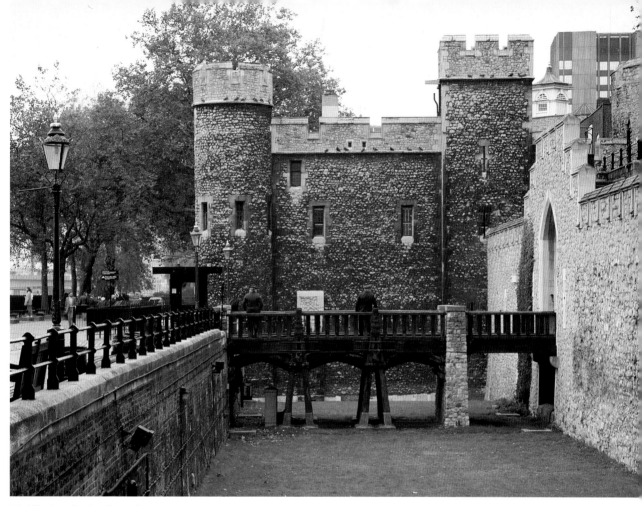

Middle drawbridge from the moat

Gallery was painted *after* his execution!

Built as the Officers' Mess in the mid nineteenth century, this building now houses the Regimental Headquarters and Museum, for which admission is charged.

St Thomas's Tower

When Edward I reclaimed land from the river to make a new outer wall the existing watergate (at Bloody Tower) became redundant. St Thomas's Tower was built in 1275–9 as a much more resplendent replacement, complete with coloured glass and statues, and the King had his own private apartments here, a bridge to the Wakefield Tower connecting them to the other royal lodgings (the present bridge is a nineteenth-century reconstruction). The southeast turret possibly contained an oratory to St Thomas à Becket, after whom the tower is named. This may be because it was felt that his ghost had to be appeased after the arch of the gate twice fell down in the course of reconstruction. The arch is remarkable in having no keystone.

Although the Wharf was extended in front of the tower in about 1338–9, the watergate continued as the main state entrance from the river. It derives the name 'Traitors' Gate' from the fact that so many prisoners accused of treason arrived at the Tower this way. One of these was Princess Elizabeth (the future Elizabeth I), accused of complicity in Wyatt's rebellion against Mary I in 1554,

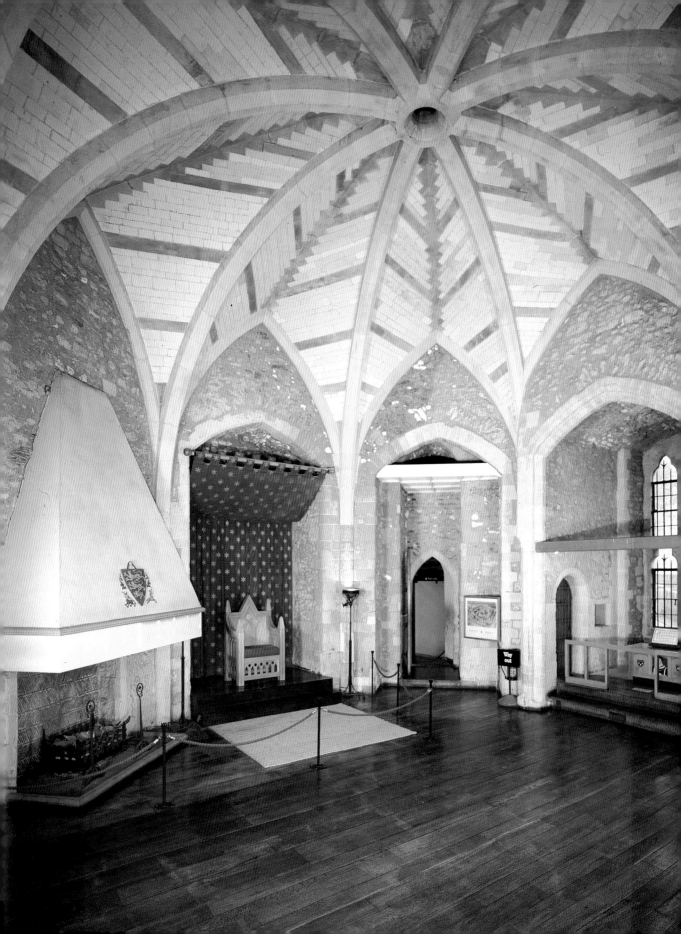

who fell on the steps leading out of the basin protesting that 'here landeth as true a subject, being a prisoner, as ever landed at these steps, and before thee, oh God, I speak it, having none other friends but thee'. Her misery can only have been increased knowing that her mother, Anne Boleyn, had come this way in 1536 for her imprisonment and execution.

The tower has been put to various uses over the years: it has housed warders, the Tower infirmary, a boring room for making gun barrels (the machinery powered in the early eighteenth century by a water engine in the pool of Traitors' Gate) and in the late nineteenth century accommodation for the Keeper of the Jewels was created here.

Salt Tower

When constructed by Henry III, this tower stood at the southeast corner of the fortress, with the river to the south of it and the moat to the east. It was designed for residential use as well as military, as the fireplace on the first floor testifies. John Baliol, erstwhile King of Scotland, occupied this tower in 1297–9 and in the thirteenth century it was still referred to as Baliol's Tower. Rather less grand prisoners were held in the tower in Elizabeth's I reign, including several Jesuits (see p. 118). One resident, Hugh Draper, carved a magnificent astronomical sphere during his imprisonment in 1561 for suspected sorcery. It is reported that some Yeoman Warders will not go near this tower at night for fear of encountering the ghosts of former prisoners, but as the Yeoman Warders' Club is not far away perhaps the stories should be taken with the proverbial pinch of salt.

Interior, Wakefield Tower

Entrance to the Well Tower, Water Lane

The upper part of the tower was restored by Anthony Salvin in 1856.

Wakefield Tower

Named after William of Wakefield, King's Clerk in 1344, and the largest tower in the fortress after the White Tower, this has specially thick walls because it was built by Henry II in 1222–40 to

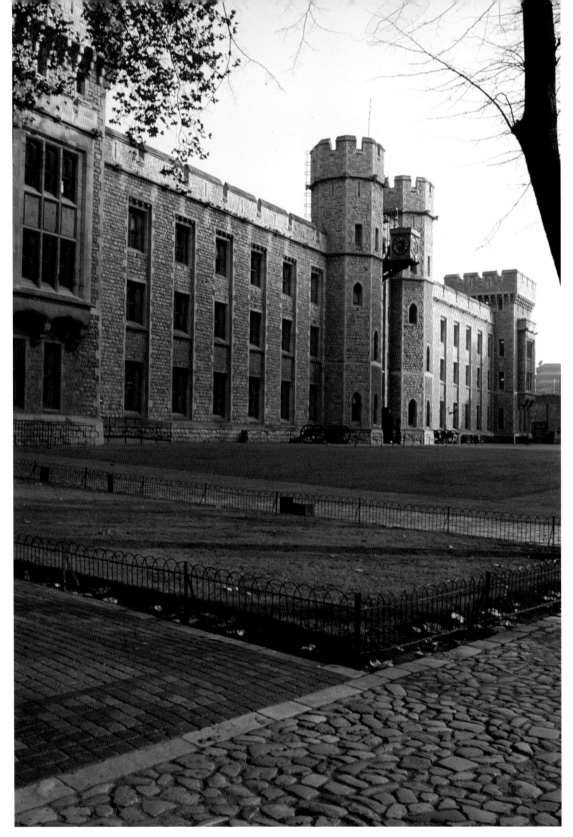

The Waterloo Block

contain his private apartments, to protect the inmost ward and to guard the 'Bloody' watergate and private postern gate on either side of it. The construction of the outer ward and St Thomas's Tower forty years later reduced its strategic importance but it continued to form part of the palace complex. It was here that Henry VI was imprisoned by Edward IV and murdered on 21 May 1471 while at prayer in the oratory. The Ceremony of the Lilies and Roses commemorates the event every year (see p. 75).

State records had been kept at the Tower of London since the reign of Edward I, initially in the Wakefield Tower, but the quantity increased, especially from the sixteenth century, to such an extent that for a period it was known as the Record Tower. Later the White Tower was also used. With the construction of the Public Records Office in the 1850s, the records were removed and the tower adapted to house the Crown Jewels. The great expansion in visitors to the Tower since the war necessitated the creation of a new Jewel House in 1967 (in the Waterloo Block), and the Wakefield Tower was then restored to its original early-thirteenth-century appearance.

Wardrobe Tower

A Roman building was probably on this site from the second century and a Roman bastion stood here from about AD400, but was superseded by the Wardrobe Tower in the mid to late twelfth century, when the Roman wall still formed the perimeter of the castle.

The Wardrobe had charge of the king's clothing, armour, equipment and treasure (the Crown Jewels are said to have been placed in the tower in 1244 while work was in progress on Westminster Abbey). In the fourteenth century this aspect of the king's household developed into the Privy Wardrobe of the Tower, responsible for arms and war stores. It was probably also at this time that a large stone building was constructed against the east side of the White Tower to accommodate the organization. Requiring more space another Wardrobe building was built from the tower to the Broad Arrow Tower during the reign of Henry VIII. This building was demolished in the reign of Charles II and the earlier structure in 1879 leaving the remains of the Wardrobe Tower as they now appear.

Waterloo Block

Originally called the Waterloo Barracks, and constructed in a castellated neo-gothic style, the building replaced the Grand Storehouse, destroyed by fire in 1841. The foundation stone, laid by the Duke of Wellington in 1845, may be seen at the northeast end of the building. The name refers to the defeat of Napoleon in 1815, and the cannons in front of the building were captured from the French at Waterloo.

Today, the block has a number of functions: it houses the Oriental Armoury, the accommodation for the Tower guard, and, since 1967, the Jewel House, at the western end of the building.

Well Tower

Part of Edward I's expansion of the castle to the south, the Well Tower not only protected the new river frontage, but also guarded the cross wall (since demolished) between it and the Salt Tower. The origin of the name probably stems from the presence of two shafts used for drawing up water.

There is a popular rumour that some prisoners were chained into one of these wells and remained there over the course of three changes of the tide. In fact, this form of execution was reserved for

pirates and took place down river at Execution Dock.

The White Tower

The White Tower, the first stone keep in England, was started in 1078 and replaced an earlier wooden fort built on the site after the Norman Conquest in 1066. It was an excellent strategic position, dominating the city and river, but the specific siting was influenced by the Roman city wall to the east (its line now marked on the grass) and the river wall to the south, together with the solid bedrock of Tower Hill, falling away to marshy ground in the east.

Probably completed in 1097, ten years after William the Conqueror's death, the tower was the tallest building in London, some ninety feet high to the battlements, and it must have impressed the citizens with the power of its occupants. Built of rough-hewn Kentish ragstone edged with finely cut Caen stone at the corners and around the windows, the design was based on the castle-palaces of the Norman dukes of the tenth century, and the work overseen by Gundulf, Bishop of Rochester. This was not as curious a choice as it may seem because in this period priests were perhaps the most experienced in building in stone, learnt through the construction of monasteries, cathedrals and churches. The Normans called the tower 'La Tour Blanche' and the white appearance was first maintained by whitewashing in the reign of Henry III (1216–72). Originally, the caps at the top of the four turrets were conical, but were replaced by the present onion-shaped ones in the sixteenth century.

The castle keep had a dual function: as military fortress and residence for the ruler. Today the official title of the Tower is still 'Her Majesty's Royal Palace and Fortress of the Tower of London'. The layout of the White Tower reflects these two roles. The entrance was at first floor level, as it is today, from a wooden staircase, which could be removed to make the entry out of reach. A further precautionary measure was placing the internal staircase, or vice, in the northeast turret, the furthest from the entrance. Accommodation for the king was provided on the second floor, which rose through two stages, the upper with a mural gallery, one of the earliest in English architecture (subsequently, possibly in the early seventeenth century, an extra floor was placed at this gallery level, and remains to this day). A door from the Great Chamber gave onto the north aisle of the Chapel of St John the Evangelist, in the southeast corner of the tower (see p. 27).

On both the first and second floors the apartments were divided by a wall running north/south which had a doorway at either end. The three recesses between have since been cut through. Apart from the two pairs of windows on the top floor above the entrance, the windows date from the eighteenth century, and give the building more light than it would have had in its medieval heyday. It seems likely that the larger room was used as a hall and the smaller was perhaps subdivided into separate chambers. The Constable of the Tower, the king's representative who commanded the fortress, probably had accommodation on the first floor and the basement was used as a storeroom with the well.

In the nine hundred years since it was built the White Tower has been used as prison, storehouse and museum. Today it houses part of the national collection of arms and armour belonging to the Royal Armouries.

The White Tower viewed from the Bloody Tower

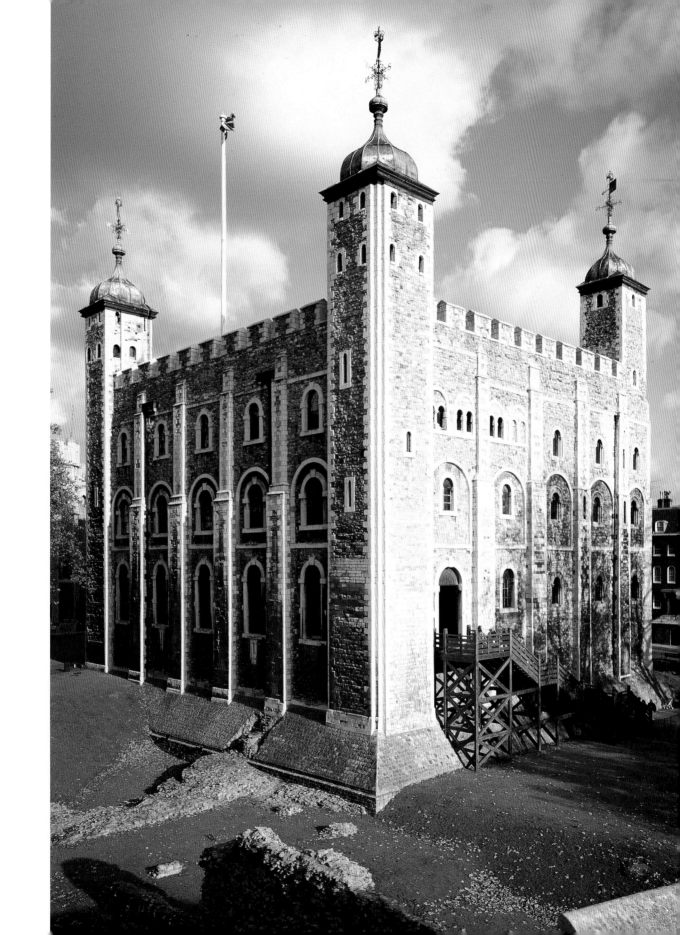

Tower Liberty marker, St Katherine's Way

The Tower Liberty

Iron gates at the main entrance

Originally, the Tower Liberty consisted of the area of land surrounding the White Tower, which was claimed as the demesne or property of the Crown, for the purpose of defending the Tower. The land comprised strips of ground to east and west of the Tower, the extent determined by the maximum reach of an arrow shot from a longbow at the Tower, and substantially more of the area to the north, known as Tower Hill, as well as the Tower ground itself. The hill was considered so crucial to the security of the Tower that in the sixteenth and seventeenth centuries new buildings were prevented from being built on the land, and attempts were made to exclude foreigners from living in the existing houses: 'it is not meet that any stranger born out of this realm should dwell within the Tower, and the liberty of the same'. The Liberty also continued to the middle of the river, with mooring facilities jealously guarded by the Tower. It also gave the Constable of the Tower the right to collect dues from ships coming up the river (see Pomp and Pageantry).

A leet jury defined the Liberty area in 1536, but boundary disputes caused James II to order an enquiry in 1686, which resulted in letters patent delineating the Tower Liberties. Three new areas were included for the first time – the Little Minories, the Old Artillery Ground and Wellclose.

People living within the Tower Liberties had certain advantages over the population of the City. They were exempt from jury service at local and county courts because the liberty had its own sessions of the peace, as well as justices, courthouse and prison. The residents were not liable for taxation by the City or County of Middlesex, and a Liberty Rate was only introduced in 1830. With the reform of local government in the late nineteenth century the autonomy of the Liberties came to an end. Today the Tower is part of the London Borough of Tower Hamlets. This is rather appropriate because at an earlier period the Constable of the Tower acted as Lord Lieutenant of the Tower Hamlets, and the Tower would call on men from the hamlets to augment the garrison at the Tower in time of need.

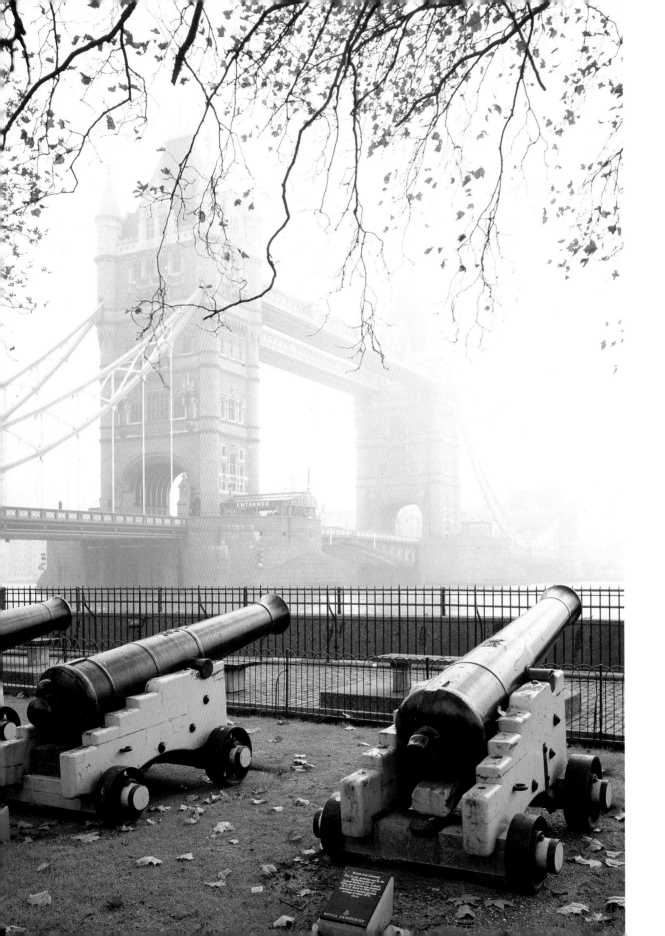

The Royal Armouries

The Tower has always been an arsenal for arms and armour, initially for its own defence, but by the mid fourteenth century it was a national depository used to supply armies and fleets. From the mid seventeenth to mid nineteenth centuries, the task of providing weapons for the British armed forces was carried out by the Board of Ordnance, whose headquarters, workshops and storehouses were at the Tower.

The Armouries were first opened to the general public after the Restoration of Charles II in 1660, and thus can claim to be Britain's first public museum. British conquests overseas in succeeding centuries augmented the collection, and in the nineteenth century items were purchased to fill gaps in the holdings. In 1985 the Armouries became the Royal Armouries, with the consent of Her Majesty the Queen, thus acknowledging both the traditional role of providing arms for the sovereign and his forces, and the museum's contemporary significance as one of the most important such collections in the world.

A detailed description of the Armouries collection can be found in the official guide, but the location of the component parts of the collection, together with a selection of some of the outstanding or unusual pieces, is given below.

Royal Armouries' cannons on Tower Wharf

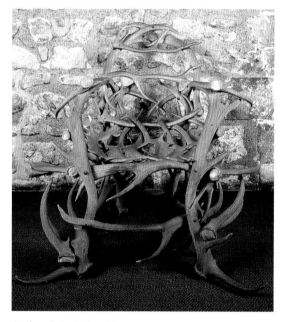

Antler chair, White Tower

White Tower

First Floor – Sporting and Tournament Armoury

- Chair made up of 12 pairs of Essex stag antlers.
- Special guns made for sportsmen who were not right-handed, could not aim with the right eye or use the right shoulder.

- 1873 Colt Frontier Revolver – one of the guns that won the West.
- Elephant guns plus part of an elephant's tusk with an iron bullet embedded in it.
- German calendar-sword, the blade etched in 1686 with a perpetual Gregorian calendar and signs of the zodiac.
- Powder horn of about 1770 engraved with a map of the Mohawk and Hudson rivers.

Second Floor – Medieval and Renaissance Armoury

- Shaffron or head-defence for a horse, probably English *c*.1400. This is the earliest surviving piece of medieval horse armour in the world. It belonged to the Earls of Warwick. (Illustrated.)
- Armour for knight and horse, German, late fifteenth century. (Illustrated.)
- Wooden saddle, Austrian or Hungarian, mid fifteenth century.
- 'Giant' armour – field armour 2.08m. (6ft 10in) tall, *c*.1535. A platform is provided for visitors to compare their size.
- Earl of Southampton's armour – a complete field armour of about 1598, bought in 1983 from Lord Astor of Hever, after a national campaign to collect the necessary funds.
- 'Lion Armour', Italian or French, *c*.1550, decorated with embossed lions' masks. A sword-cut can be seen on the helmet.

Third Floor – Tudor and Stuart Armoury

- Grotesque helmet from a parade armour probably presented to Henry VIII by Emperor Maximilian I, in 1514. (Illustrated.)
- Two armours for foot combat for Henry VIII to wear at the Field of Cloth of Gold in 1520.
- Henry VIII's armour garniture of 1540 (includ-

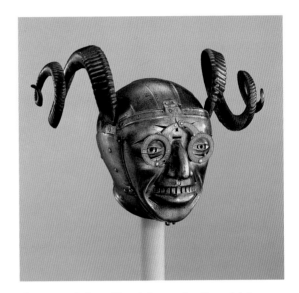

Grotesque helmet (Royal Armouries Copyright)

ing the famous codpiece). The decoration on the borders designed in part by Hans Holbein the Younger. (Illustrated.)
- Light field armour for a boy *c*.1550, possibly made for Edward VI.
- Complete field armour probably made for Charles I as a boy and also worn by Charles II.
- Small armour 0.95m. (37 inches) tall. English *c*.1630. May have been made for Captain Jeffrey Hudson, dwarf in the service of Queen Henrietta Maria.

Basement – Mortar room, Old Armoury, Cannon room

- Old Armoury contains relics from the Line of Kings (see p. 122) including a light dun horse carved by Grinling Gibbons. Also designs,

German knight and horse armour; English Shaffron

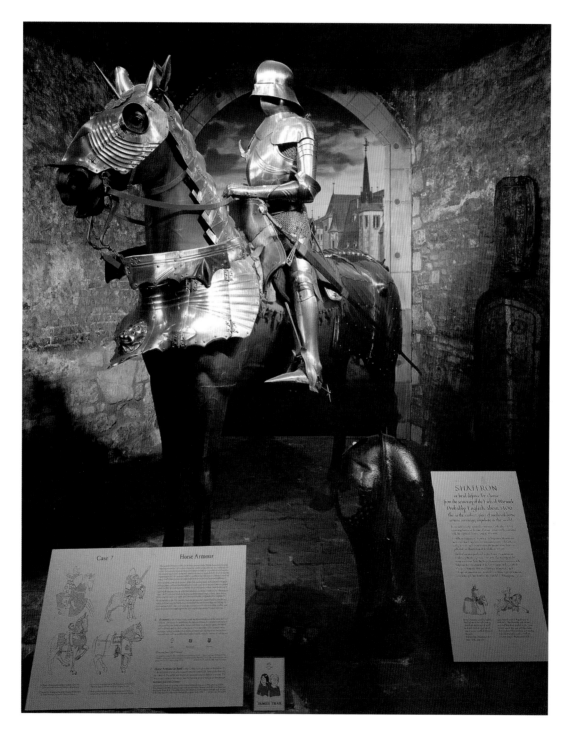

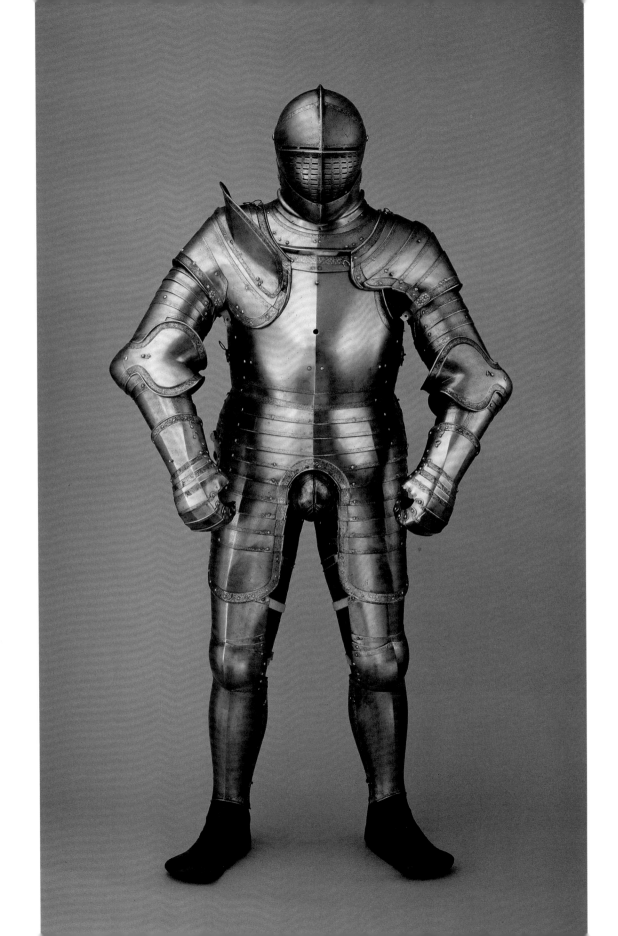

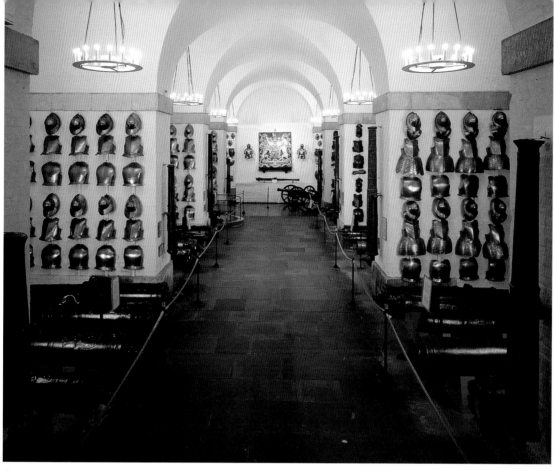

Cannon room in the basement of the White Tower

Well, White Tower basement

OPPOSITE *Henry VIII's armour garniture of 1540 (Royal Armouries Copyright)*

made from weapons, created in the 1690s for display in the Grand Storehouse, for example a serpent made from gun screws.

New Armouries

Ground Floor – British Military Armoury

- The only surviving storehouse of the Board of Ordnance, it contains relics from the Grand Storehouse, completed in 1692, destroyed by fire in 1841 (see p. 124). These include melted and fused weapons, designs made from weapons (as in the basement of the White Tower), for example a bird in flight made from gun triggers, and the pediment of the building itself.
- Exploded view of all the parts of a sea service pistol.

47

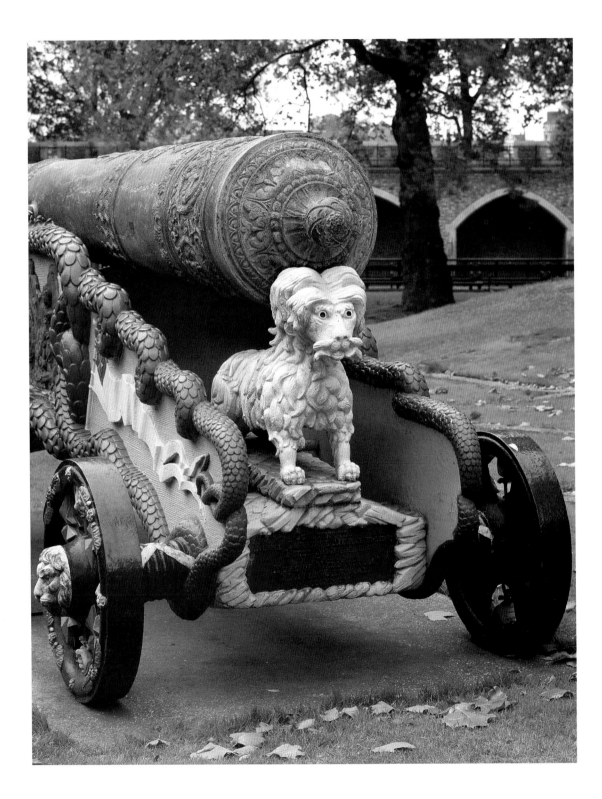

First Floor – Eighteenth and Nineteenth Century Armour

- Pair of cavalry kettle drums captured from the French at Blenheim in 1704.
- Gun made at the Tower for Thomas, 1st Earl Coningsby, during his brief imprisonment at the Tower in 1721. A rhyming inscription in gold on the gun tells the story. It was made from the blades of swords taken from the rebels in the 1715 rebellion.
- Miniature guns and swords for children.
- 1786 sword of Napoleon Bonaparte.
- Duelling weapons.
- Early machine guns including the Gatling and the Maxim.
- Browning automatic pistol (Belgian, 1900) like the one used to assassinate Archduke Franz Ferdinand at Sarajevo in 1914.
- Smallest functioning automatic pistol ever commercially manufactured. German 1913–14.

Waterloo Block

Oriental Armoury

- Indian elephant armour, probably early seventeenth century.
- Cannons and mortars in the shapes of tigers and dragons.
- Tibetan cavalry armour of seventeenth to nineteenth centuries.
- Japanese samurai armour.

Herald's Museum

- Display explaining family emblems.
- Guide to how coins and medals are struck.

Of related interest but not part of the Royal Armouries:

Martin Tower

Instruments of Torture and Punishment

- Block used for the execution of Lord Lovat in 1747. Traditionally the block was burnt after an execution, in part to prevent it becoming a martyr's symbol.
- The 'Scavenger's Daughter', invention of Leonard Skeffington, Lieutenant of the Tower in Henry VIII's reign, compressed the body, whereas the rack, the 'Duke of Exeter's Daughter', named after the fourth Duke of Exeter, Constable in the fifteenth century, pulled the body apart.

Museum of the Royal Regiment of Fusiliers

- Accounts of campaigns the regiment has been involved in, such as the American War of Independence, the Napoleonic Wars, the Crimea, the Boer War and the two World Wars.
- Copy of a metal boot used in 1808 on a malingerer – to prevent him applying a corrosive substance which kept open a sore on his leg for three and a half years. After the boot was applied he was cured in twelve days.
- Original Victoria Cross struck in 1856 for Queen Victoria's approval. Also on display are Victoria Crosses won by members of the regiment.
- Relics from Younghusband's 1904 expedition to Tibet, including goggles issued to the troops to prevent snowblindness.

Detail of dog, Flemish cannon

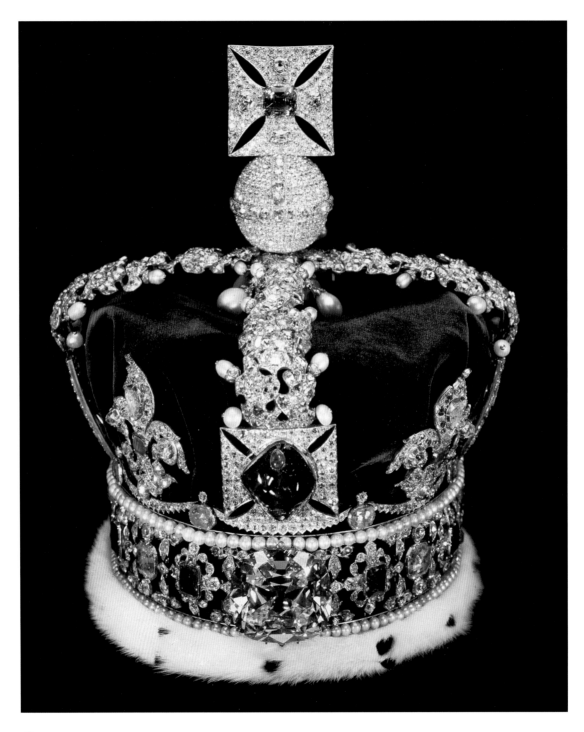

The Crown Jewels

Traditionally, Crown Jewels were the personal property of the sovereign and therefore, in the medieval period, he would sometimes pawn them or use them as security for loans in time of war. Some were kept at the Tower, particularly when the sovereign was in residence there, while the Coronation Regalia was held at Westminster Abbey. It was only after 1660, when a new set of Regalia was made to replace that destroyed during the Commonwealth, that the Tower became the permanent home of the Crown Jewels, and they were put on public display.

The Jewel House (in the Waterloo Block) is open for the same hours as the Tower (see p. 81 for times), but please note that the Jewel House is closed for a month in January/February (check with the Tower for the exact dates each year), for the annual cleaning of the Jewels by Garrards, the Crown Jewellers. This is done at the Tower under strict security. It is advisable for those wishing to avoid the queues, particularly in the summer months, to come to the Tower as soon as it opens in the morning, and go to the Jewel House first. The price of admission is included in the entry charge to the Tower. Visitors who suffer from claustrophobia are advised that in the event of an alarm, they may find themselves locked in and unable to leave when they want!

The exhibition on the ground floor is of banqueting and church plate, swords of state, maces, trumpets, orders of chivalry, other decorations and the Coronation Robes. Visitors then descend to the basement, where the Crowns and Coronation Regalia are displayed. There are two tiers from which you can view the Jewels: on the lower one you will be kept moving, but on the higher and more distant one, you can view them at your leisure (even with binoculars, if approved by the wardens!). The Jewel House Wardens will be happy to answer any questions, but the Curator of the Crown Jewels gave me an answer to the most common question 'What is the value of the Jewels?'

'You could estimate the value of all the gold, silver and platinum in the collection, I suppose, and the value of all the diamonds, sapphires, rubies, emeralds and pearls, but how do you value the antiquity and the royal ownership, the fact that these crowns have all been worn by kings and queens of England? How much are the Crown Jewels worth? They are priceless, beyond price. To price something, you must have a comparable thing as a yardstick. There is, quite simply, nothing to compare with the British Crown Jewels. And that is the best and most honest answer I can give you.'

Imperial State Crown (Crown Copyright)

A full description of the Crown Jewels and State Regalia is given in the guidebook, *The Crown Jewels*, available at the Tower shops, but an outline of the most important items is given below.

Imperial Crown of India

Created in 1911 for George V to wear at the Delhi Durbar, this crown contains 6,004 precious stones sent by the Maharajahs of India, mostly diamonds perfectly matched for colour, clarity and gem weight. It had to be made because constitutional convention prevents English crowns from being taken abroad. This is probably a result of earlier kings pawning or selling the Crown Jewels to raise money for foreign wars (see p. 106).

George V was the (first and) last English king crowned Emperor of India, so this crown has not been used since then. It seems a shame, because in the opinion of the Curator of the Crown Jewels this is 'as perfect a crown as you can get'.

Crown of Queen Elizabeth the Queen Mother

This crown, the only one made of platinum, was created for the 1937 coronation. With the arches removed, it was also worn by the Queen Mother at Elizabeth II's coronation in 1953. The crown is noteworthy because set in the Maltese Cross at the front is the famous Koh-i-noor diamond, transferred from Queen Mary's Crown. Found near Hyderabad in India in 1655, and then weighing some 787 carats, the diamond belonged to various rulers in India, Persia and Afghanistan before being given to Queen Victoria by the East India Company in 1850, by which time it had been cut to 186 carats. Prince Albert ordered it to be recut to its present 106 carats. Thought unlucky if its owner is a man, the diamond has always been placed in the queen consort's crown.

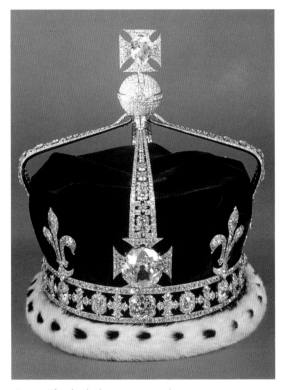

Queen Elizabeth the Queen Mother's Crown (Crown Copyright)

St Edward's Crown

The lower half was made from one of three crowns to survive Cromwell's destruction of the Crown Jewels, and it may have been the crown of Edward the Confessor (1042–66). It was remodelled for Charles II. Since then, it has been used to crown the sovereign, at the climax of the coronation ceremony. Made of gold and set with semi-precious stones, the crown is extremely heavy, weighing an ounce under 5lb (2.3kg). The present stones date from George V's coronation

Imperial Crown of India (Crown Copyright)

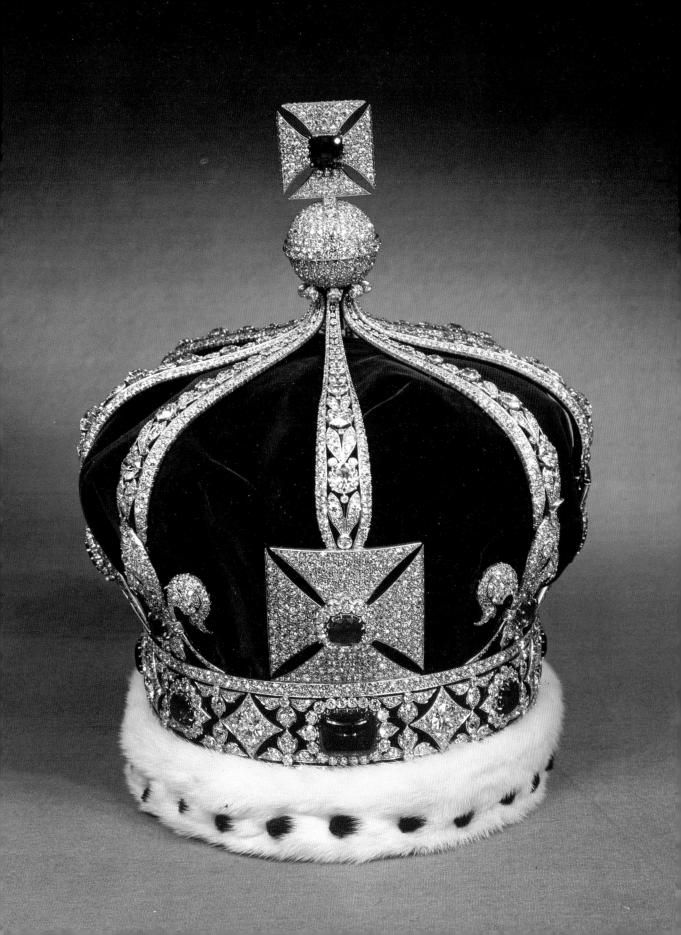

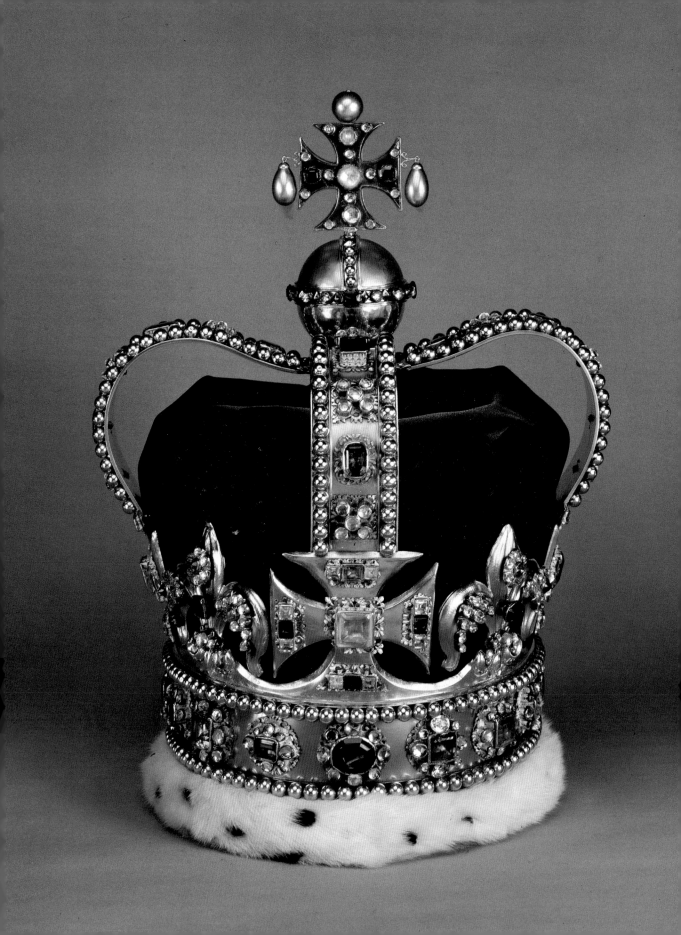

in 1911; prior to that stones were hired for each coronation from a jeweller, and the crown set with crystals in the interim.

Ampulla and Spoon

The anointing of the sovereign takes place early in the coronation ceremony. The Archbishop of Canterbury pours the holy oil from the gold ampulla, via the eagle's beak, into the Anointing Spoon, and then touches the sovereign on the hands, breast and head. The eagle's head dates from the fourteenth century, but the body and stand were made for Charles II's coronation. The Spoon, used at the coronation of King John in 1199, is the oldest piece of the Regalia. The four pearls were added for William and Mary's coronation in 1689.

Imperial State Crown

This is the most well known of the Crown Jewels because it is seen at state occasions such as the Opening of Parliament, as well as being worn by the sovereign when leaving Westminster Abbey after the coronation.

The crown was made for Queen Victoria in 1837, and has 3737 precious stones, including 2800 diamonds, but is most famous for its historic gemstones. The sapphire set into the Maltese Cross at the top is said to come from Edward the Confessor's ring at the time of his re-interment in Westminster Abbey in 1163. Set in another Maltese Cross at the front of the crown is the Black Prince's Ruby, actually a pierced balas or red spinel filled with a true ruby. Given to the Black Prince by the King of Castile in 1367, it was

St Edward's Crown (Crown Copyright)

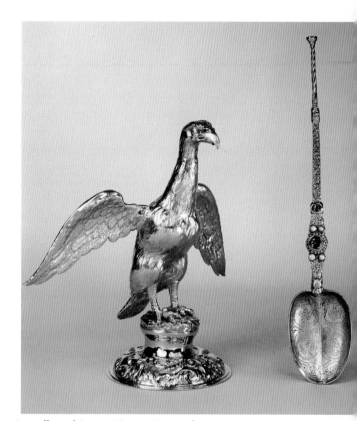

Ampulla and Spoon (Crown Copyright)

worn by Henry V at the Battle of Agincourt in 1415. Below this, set in the circlet, is the Second Star of Africa, the second largest diamond in the world, cut from the Cullinan diamond. This replaced the Stuart Sapphire in 1911, which was then moved to the back of the crown. Very large, at some 104 carats, the sapphire was probably in the Scottish Crown used at the coronation of Alexander II in 1214.

The Sceptres

The sovereign is invested with the Sceptre with the Cross and the Sceptre with the Dove immediately

prior to being crowned. The first sceptre represents the sovereign's temporal power and the second his (or her) equity and mercy.

They were both made for Charles II's coronation, but the Sceptre with the Cross was remade in 1910 to hold the First Star of Africa, the largest cut diamond in the world, weighing 530 carats. It came from the Cullinan diamond, given to Edward VII by the Transvaal Government in 1907. Then weighing 3106 carats, the King had it cut into nine major diamonds and ninety-six minor ones. The two largest were used in the Crown Jewels (see also Imperial State Crown) and the remaining seven are the personal property of Elizabeth II.

The Crown Jewels and State Regalia

A CHRONOLOGY

1042 Essentials of modern coronation ceremony established by Edward the Confessor. Today his crown forms the base of St Edward's Crown.

1649 Following the execution of Charles I, Oliver Cromwell appointed a commission to dispose of the Crown Jewels and Regalia. They were sold or melted down for coinage.

1660 After the Restoration, new Regalia was made for the coronation of Charles II at a cost of £31,000 9s 11d.

1669 Crown Jewels put on public display in the Martin Tower.

1671 Colonel Blood attempted to steal the Crown, Orb and a Sceptre.

1689 An additional set of Regalia was made for

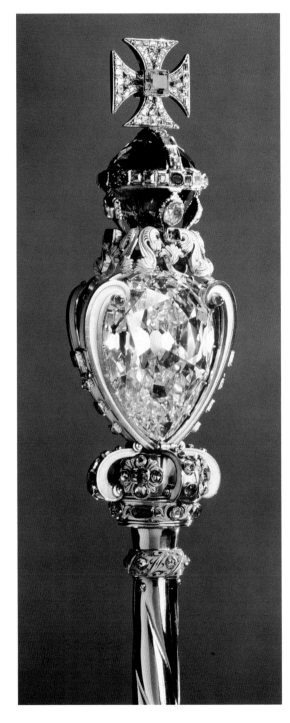

Sceptre with the Cross (Crown Copyright)

the coronation of William and Mary because Mary was Queen in her own right, not Queen Consort.

1815 Public handling of the Crown Jewels ceased after a madwoman bent the arches of the State Crown. This crown was replaced by the present Imperial State Crown in 1837.

1821 George IV made several additions to the Jewels and Regalia, for example the Coronation Robes and the Jewelled State Sword, the latter made at a cost of £5,998.

1841 The Grand Storehouse fire threatened the Crown Jewels in the Martin Tower. They were rescued at the last minute.

Purpose-built neo-gothic Jewel House built to the south of Martin Tower.

1869 The Crown Jewels were moved to the Wakefield Tower due to poor heating and lighting in the new building, which was then demolished.

1870 Small crown (4oz) containing 2,300 diamonds was made for Queen Victoria because she did not like wearing the large Imperial State Crown.

1902 Prince of Wales Crown made for Prince George, the future George V, to wear at the coronation of Edward VII. Subsequently in the possession of Edward, Prince of Wales (later Edward VIII and Duke of Windsor), it only returned to the collection after his death in 1972.

1905 Cullinan diamond discovered in South Africa.

1910 Star of Africa inserted into the Imperial State Crown.

1911 Imperial Crown of India made for George V to wear at the Delhi Durbar.

1937 Queen Mary (widow of George V) broke with tradition by attending the coronation of her husband's successor (George VI). Queen Elizabeth the Queen Mother followed suit in 1953.

1953 Stole and new Armills presented to Elizabeth II by the Commonwealth nations of which she was titular head.

1967 New Jewel House opened in the Waterloo Block.

1975 Two Caddinets of 1683 and 1689, sold in 1808, reacquired and put on display.

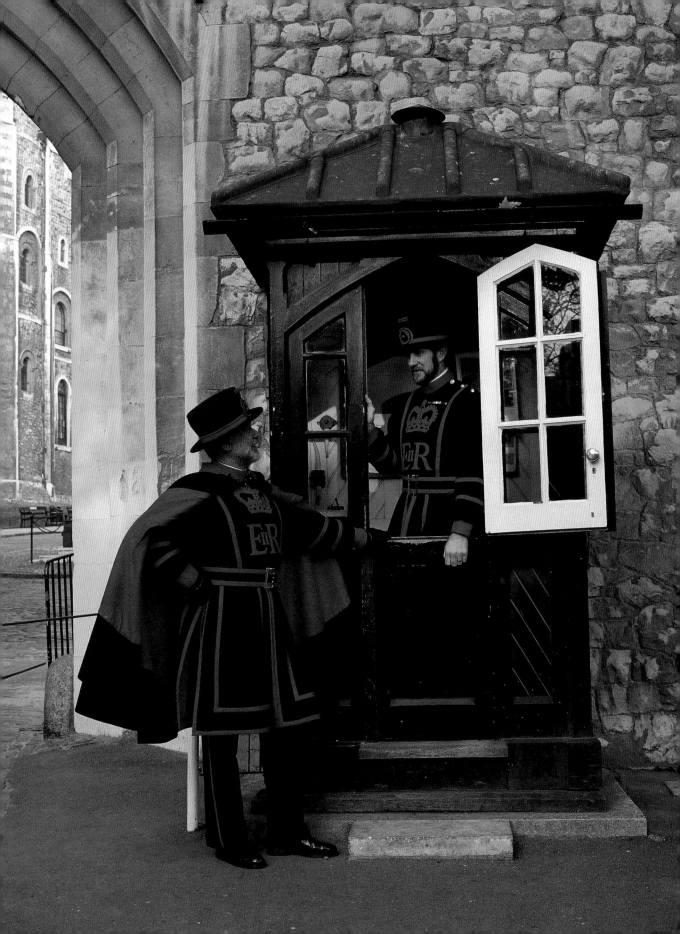

The Yeoman Warders and other people of the Tower

Since October 1989 the Tower of London has been one of five royal palaces managed by the Historic Royal Palaces Agency, part of the Department of the Environment. The HRPA is run by a Chief Executive responsible to the Secretary of State. Details of the functions, past and present, of personnel connected with the Tower itself are given below.

The Constable

The office of Constable dates from the eleventh century, when Geoffrey de Mandeville was appointed by William the Conqueror as the sovereign's representative with local command of the Tower. The post continues to this day, although the daily administration of the fortress is overseen by the Governor (see below). The Constable no longer lives in the Tower, and probably has not done so since the reign of Elizabeth I.

The Constable has always been a man of distinction (with the occasional bad penny such as Geoffrey de Mandeville, Earl of Essex, grandson of the first Constable, who seems to have been something of a highwayman and resigned the post after three years) and since 1784 has been a high-ranking Army officer. To date there have been

Yeoman Warders Butler and David by east drawbridge

156 Constables including such well-known public figures as Thomas à Becket and the Duke of Wellington. Until the 1930s the appointment was for life but since then has been for a term of five years. The job is unpaid but Constables were entitled to certain perquisites, e.g. the fees from state prisoners and all cattle that fell off London Bridge.

The Lieutenant

In the sixteenth and seventeenth centuries the Constable's duties at the Tower were carried out by the Lieutenant, who lived in the Lieutenant's Lodgings (now the Queen's House). But from the late seventeenth century the job devolved onto the Deputy Lieutenant, and the Lieutenant ceased to live at the Tower.

Today the Lieutenant is a largely honorary post held by a retired army officer for three years. He stands in for the Constable or Governor as occasion demands.

The Governor

There has always been someone in local command of the Tower, originally the Constable, then Lieutenant, followed by a Deputy Lieutenant and Major, and since 1858 the Resident Governor or Governor. Until 1989 he was always an Army officer nominated by the Ministry of Defence, but

Yeoman Warder Sharples in red ceremonial dress

since the setting up of the HRPA recruitment has been through open competition. The Governor is one of four palace managers within the Agency responsible to the Chief Executive for day to day management. The post is for five years unless renewed, and carries the privilege of living in the Queen's House.

The Governor is assisted by three senior staff, in charge, respectively, of administration, security, and commercial services. The person in charge of the administration is a serving army officer (from the Royal Army Ordnance Corps) and his duties include responsibility for the Ordnance depot at

the Tower. The other two posts are held by Civil Service appointees.

The Yeoman Warders

These gentlemen are among the most famous features of the Tower, and are familiarly known as Beefeaters. However, this term is not correct, having no historical basis, and should not be used.

The Tower has always had a body of retainers to guard the gates and prisoners, but the Yeoman Body dates from the reign of Henry VII. It was in 1550, at the request of Edward Seymour, Duke of Somerset, a grateful former prisoner at the Tower, that the Yeoman Warders were made extraordinary members of the Yeomen of the Guard and entitled to wear royal livery. The present style of state livery dates from Queen Victoria's reign, as does the blue undress uniform (which most visitors see today), introduced in 1858. The latter uniform comes in two weights, for winter and summer. In winter more layers can be worn underneath the uniform, and a cape worn on top, but on a hot day in summer the outfit can be quite uncomfortable.

The warders or 'Waiters' (guard duty is still known as 'the Wait') could purchase their post, and hold it for life, for 250 guineas (£262.50), but the quality of those doing the job soon left something to be desired. As early as 1608 the Lieutenant, Sir William Waad wrote, 'many perform their waitings by a deputy and seldom come to give attendance, being farmers in the country, others citizens, others artificers, some bankrupts, some given to drunkenness and disorder, and most of them very ungovernable'. It was the Duke of Wellington who ended this

Chief Yeoman Warder in state dress

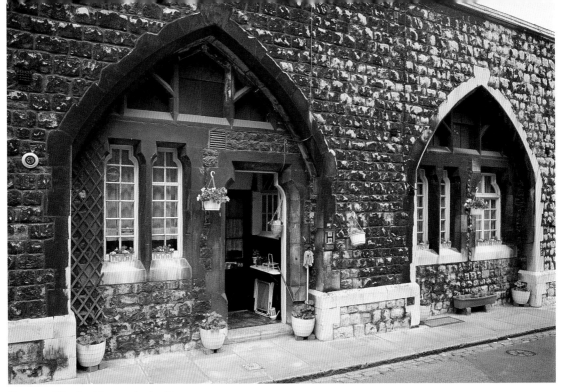

Yeoman Warders' homes in the Casemates

system and ordered that 'no person should be admitted to be a warder of the Tower of London but deserving, gallant and meritorious sergeants from the army', who would be paid a salary.

Today the Yeoman Body is made up of about forty-two former non-commissioned officers from the Army, Royal Marines and Royal Air Force, each with a minimum of twenty-two years service, and the long service and good conduct medal. It is said that the Navy is excluded because in the past many crews were recruited by press gangs and so never swore allegiance to the sovereign. On average two places a year become vacant, and about twenty-five applications reach the Tower in the same period. Candidates have to be recommended by their senior officer and as part of the selection process are invited to visit the Tower (with their spouse, if they are married) to be interviewed by the Governor. Part of his task is to assess if the couple will fit into the tightknit Tower

Warders outside the Yeoman Warders Club

community. A condition of appointment is that they have to live at the Tower and so they and their families make a vital contribution to the 150-strong population of the Tower.

Warders are mostly accommodated in the Casemates, but some live in towers closed to the public, and these are offered to new warders in the order they become available. If a warder has a large family he has to wait until a large apartment becomes free. The rent is subsidized. Inevitably living at the Tower has its negative as well as positive points. From a practical point of view it can be inconvenient because it is a long way to the shops, and entering the Tower after it has closed for the night can present problems. However, visitors might be surprised to see such normal events as the milkman and postman at the Tower on their daily rounds, and the Tower doctor holds regular surgeries. In the moat there are swings, tennis courts and a bowling green for the use of the Tower residents, and the Yeoman Warders have their own 'pub' – the Club situated in the outer wall between the Cradle and Well Towers. Being Crown property it is exempt from normal opening restrictions. It is filled with all sorts of Yeoman memorabilia – cartoons featuring Yeoman Warders, taken from national newspapers, pewter mugs each engraved with the name of a serving warder, used for the traditional toast (see p. 75), and crests presented by regiments which have served on guard duty at the Tower.

The warders provide a valuable guiding service for Tower visitors. Before being allowed to take a tour they have to do a dummy run with the Governor and the Chief Yeoman Warder to prove their competency. Another task is the traditional one of guarding the gates. Because of this each warder is sworn in as a Special Constable of the Metropolitan Police Force by a Magistrate. This is one of three swearing-in ceremonies a new

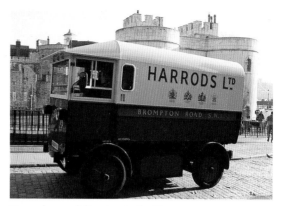

Harrods van delivering to the Tower
(B. Ramamrutham)

Laundry drying on the roof of the Casemates

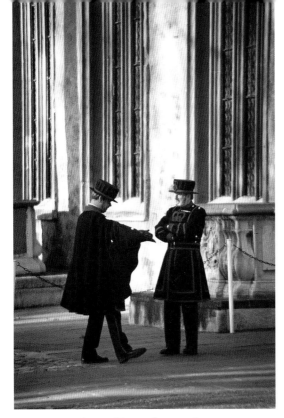

Yeoman Warders in blue undress uniform

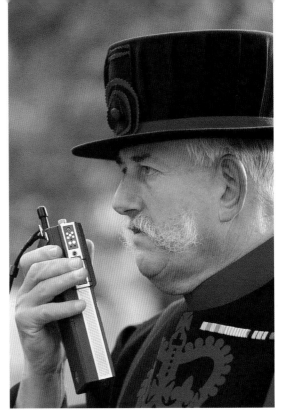

Yeoman Warder Hubble with walkie-talkie
(B. Ramamrutham)

warder has to take part in. One other takes place at St James's Palace when the warder is enrolled as a member of the Queen's Bodyguard of the Yeomen of the Guard Extraordinary. The third ceremony takes place at the Tower (see p. 75).

Technically the warders are Civil Servants with the pay and service conditions of museum warders, though the title does not exactly fit all their responsibilities. Yeoman Warders attend the coronation of the sovereign, lying in states, the Lord Mayor's Show and other state and charity functions. Many of the warders are also generous with their time (and they only have one day off in six) in charitable work. The sight of a Yeoman Warder in his blue undress uniform has cheered many a sick child.

Warders occupy certain posts for which they are selected by a special committee: Raven Master, Clerk and Sexton to the Chapel, Chief Yeoman Warder, Yeoman Gaoler and Yeoman Clerk. The Chief Yeoman Warder is the heir of the Yeoman

Yeoman Gaoler's arm badge

Porter who was in charge of the gates. Prisoners were the responsibility of the Gentleman Gaoler, historically the more senior position. It was the Gaoler who, with his ceremonial axe, would accompany prisoners to and from their trials, often held at Westminster. On the outward journey the axe blade faced away from the prisoner, but if the verdict was guilty it would be turned towards him on the trip back to the Tower. The axe is still carried on parades by the Yeoman Gaoler, a title which dates from 1861.

Jewel House Wardens

There are twenty-four wardens working in the Jewel House, overseen by the curator and two assistant curators. There is no requirement of military service, as with the Yeoman Warders, but several of the wardens have served in the armed forces. All wardens are expected to have a good knowledge of the collection, and undergo a four to six week training in the history of the exhibits.

Market research has shown that ninety-eight per cent of visitors to the Tower come to see the Crown Jewels and the numbers of people the wardens have to oversee is remarkable. In 1977 the number of visitors averaged 11,500 per day, meaning twenty-seven people entering and leaving every minute of every day that the Jewel House was open. The wardens have an important function in making sure the visitors are kept moving, slow enough so everyone can see the Jewels, but fast enough so the queues do not get too long.

Jewel House Wardens

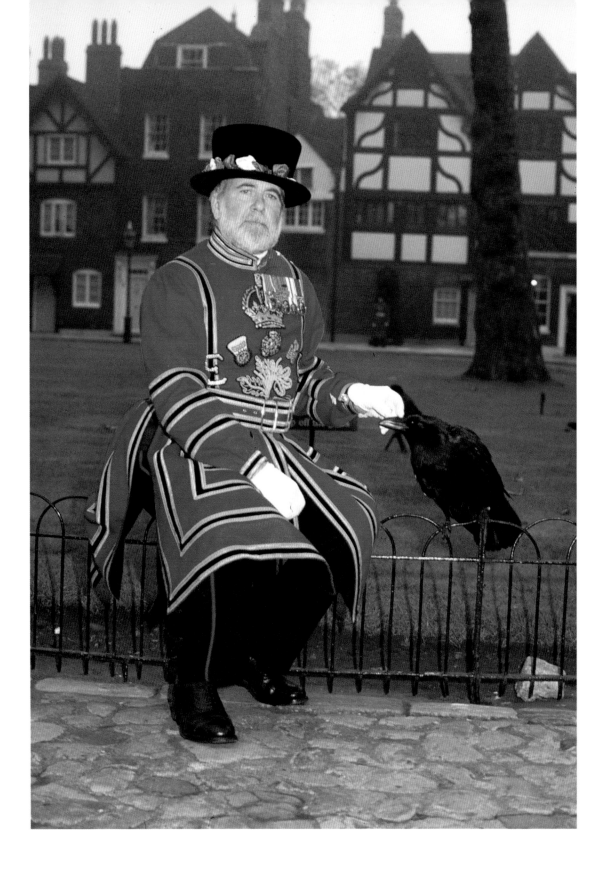

The Ravens

The raven is the largest member of the crow family and has appeared in myths and legends in many countries over thousands of years. According to the Bible ravens were given room in Noah's Ark and it was a raven which was sent forth before the dove to see if the flood waters had abated. But in the course of time these birds have become associated with evil omens, no doubt in part due to their sinister black plumage, and because they are scavengers.

There have probably been ravens at the Tower since its inception, the settlement there providing plenty of refuse for the birds to feed on. At what point they achieved their present honourable status is not known. But there is a story that Charles II, while stargazing from the newly established observatory in the northeast turret of the White Tower, had his view obscured by bird droppings on the telescope. In his anger the King ordered that the ravens should be destroyed, only to be told of the legend that without ravens the Tower would fall and the kingdom too. Charles, the first king of the restored monarchy, was disinclined to do anything which threatened his position and so, according to the tale, the ravens were spared and the observatory was moved to Greenwich (see p. 123).

Yeoman Raven Master with Ronald Raven

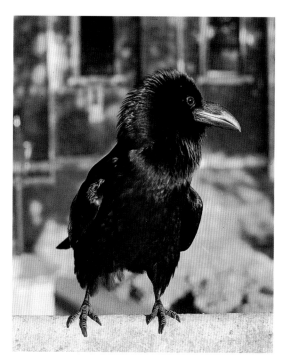

Raven on a wall

The legend was confounded in 1946 when there were no ravens at the Tower, but since this was just after World War II when the kingdom had come perilously close to falling, perhaps there is some connection. Since then, there have always been six ravens at the Tower, plus two auxiliaries, and they live in a cage near the Wakefield Tower.

67

A raven on a wall by the White Tower

One of the Yeoman Warders acts as Raven Master, and is provided with ration money to keep the ravens properly fed, with among other things, meat from Smithfield market. Here then are the true beefeaters of the Tower!

To keep the ravens at the Tower, their wings are clipped on one side. This is a painless process, but one which makes them look rather ungainly and alters their aerodynamic capabilities so that they cannot fly. The combination of the inability to court in flight and the lack of space and privacy at the Tower have always made breeding difficult, and the full complement is usually maintained by bringing in replacement birds when needed. However, in 1989, ravens Charlie and Rhys produced an egg which successfully hatched. This was such an unusual event that the young raven, together with the Raven Master, appeared on

BBC's 'Blue Peter', a children's television pro-
gramme. Viewers were invited to suggest a name
and the one picked at random was Ronald Raven,
a pun on former US president, Ronald Reagan,
who had just received an honorary knighthood.
Ronald has joined his fellows, who include
Hardey (*sic*), named after the author Thomas
Hardy, and Larry, who took the name of the
coastguard who rescued him. By 1990 Ronald had
five siblings(!), none allowed to be Tower
residents, however.

Ravens are long-lived, usually about twenty-
five years, but one, James Crow, is said to have
been forty-four when he died. There is a special
raven memorial in the moat, to the east of St
Thomas's Tower. However, some are not listed
because the ravens can be dismissed for miscon-
duct, as happened to George, who received his
marching orders in 1986 for biting the Governor:
'On Saturday, 13 September 1986, Raven George,
enlisted in 1975, was posted to the Welsh Moun-
tain Zoo. Conduct unsatisfactory, services there-
fore no longer required.' Visitors should bear in
mind that these are wild birds and although they
cope very well with the large number of people,
they do not like to be poked or prodded. Enjoy
them at a distance, and if you are quiet and patient
enough, they will reward you by posing for a
photograph. Take heart from my experience:

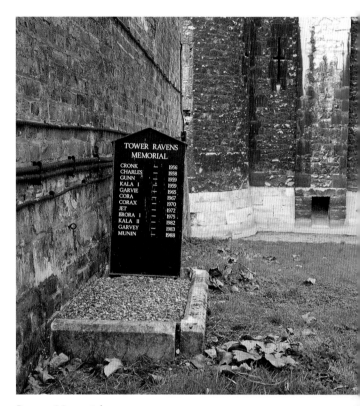

Ravens Memorial

Ronald Raven and I are now sufficient friends that
he no longer pecks at my outstretched hand or
motorcycle boots.

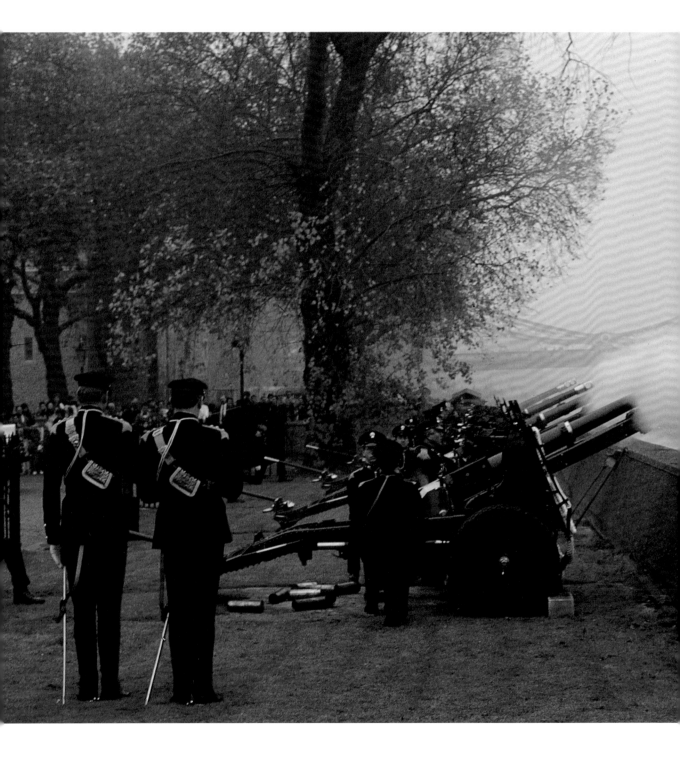

Pomp and Pageantry

The Tower of London is often called 'a living history book', and its traditional ceremonies, enacted in virtually the same way for centuries, give substance to this description. Some are to do with security at the Tower, others associated with past inhabitants or specific occasions, but it is important to remember that these are not empty rituals, but have a function, however symbolic, in keeping tradition alive and honouring the Tower as a royal institution. For this reason the Tower personnel carry them out meticulously, and where possible they are worth witnessing. Some occur daily, others more infrequently, some are open to the public, others private. The ceremonies are detailed below, followed by a calendar of events in the Tower year.

Changing the Guard

The body of soldiers that guards the Tower is usually taken from one of the five regiments of Foot Guards who also provide the guard at Buckingham Palace and St James's Palace. Other regiments may also perform public duties. The guard consists of one officer, five non-commissioned officers, fifteen guardsmen and a drummer. At

Royal gun salute

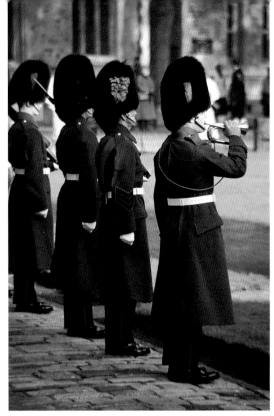

Changing of the Guard

'Clockwork soldier', Waterloo Block

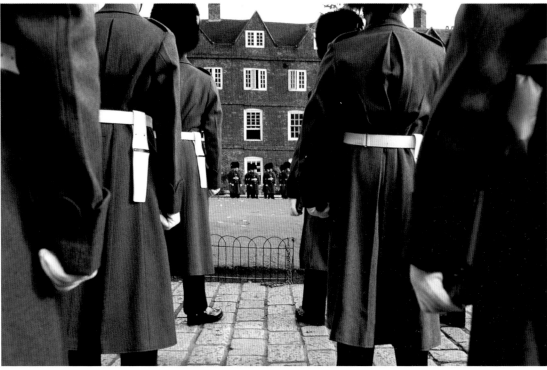

Changing of the Guard

11.30am (every day in summer, every alternate day in winter) the 'new' guard replace the 'old' guard on Tower Green.

Visitors may be curious about why the two officers are constantly on the move. Traditionally this is so that the officers could be seen by all their troops and for security reasons – it is harder to shoot at a moving target.

Coldstream Guardsman on duty, Waterloo Block

Guardsmen marching to the Queen's House

Relief of Sentries

Every two hours (one in inclement weather), the sentries in front of the Queen's House and Waterloo Block are replaced by other soldiers under orders of a non-commissioned officer.

Ceremony of the Keys

Dating back some 700 years, this ceremony is part of securing the fortress for the night, and takes place every evening at 10pm. The Chief Yeoman Warder, with military escort, locks the outer,

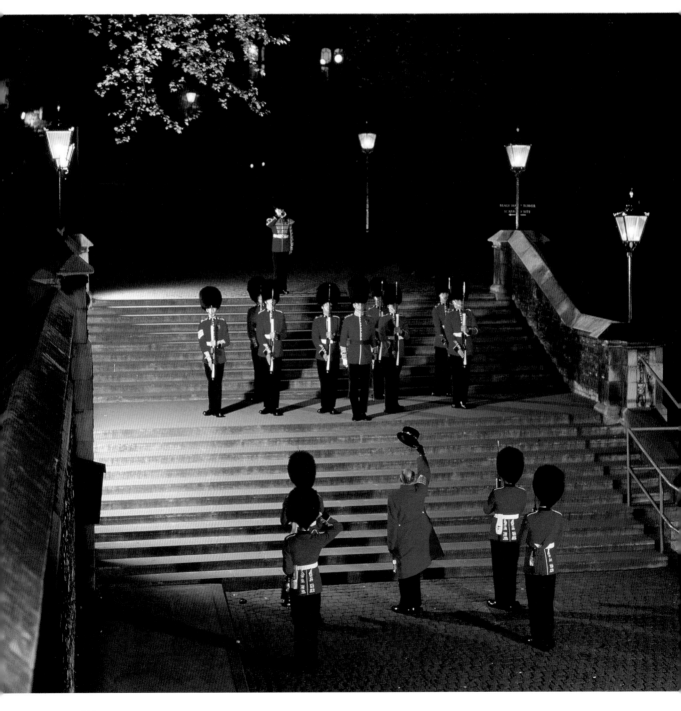

Middle and Byward Tower gates, and then when he tries to enter the inner ward at the Bloody Tower, he is challenged by a sentry. Having identified the Keys as those of the sovereign, and been saluted by the Tower Guard, the Chief Yeoman Warder gives them to the Governor for the night.

Admission for the public is by ticket only, obtained by writing in advance to the Governor. Tickets are free but it is advisable to write early, giving alternative dates, particularly for the summer months. Up to seventy people are allowed per night. Incidentally, although the fortress has been locked for the night, you will be let out after the ceremony!

Gun Salutes

Anne Boleyn's coronation in 1533 was marked by one of the first recorded salutes and since then guns have been fired to mark a variety of occasions. Today they are fired on state visits, for the Opening of Parliament, royal births, birthdays, and the accession and coronation of the monarch. The number of blank rounds used depends on the event – 41 for state visits, 62 for royal occasions. The Honourable Artillery Company, the oldest armed body in Britain (they received their charter from Henry VIII), fires the salutes from 25-pounder guns which they bring to the Gun Park on Tower Wharf. This ceremony can be witnessed by the public and royal salutes take place at 1 pm on the relevant day; for state visits, the first round is coordinated by radio to coincide with the moment the dignitary steps off the train at Victoria Station.

Ceremony of the Keys (Crown Copyright)

State Parades

At Easter, Whitsun and the Sunday before Christmas, Yeoman Warders in state dress escort the Governor from the Queen's House to a service in the Chapel of St Peter ad Vincula, and back again. The parade takes place fifteen minutes before the service. Members of the public may attend the service, by prior written consent.

Anne Boleyn's Memorial

In honour of Anne Boleyn, 'an anonymous French society' has, for some years, placed a basket of red roses on her burial site in the Chapel of St Peter ad Vincula, on the anniversary of her death on 19 May 1536.

Ceremony of the Lilies and Roses

This private ceremony takes place every year on 21 May, in the Wakefield Tower. A short service is attended by the Provosts of Eton College and King's College, Cambridge. Then they lay their college emblems (respectively, Eton lilies and white roses) on the plaque marking the spot where Henry VI, founder of both institutions, is said to have been murdered on 21 May 1471. The tradition was started by Eton in the 1920s and King's began to participate in 1947.

Swearing in of Yeoman Warders

A new Yeoman Warder is sworn in on Tower Green by the Governor in the presence of the Yeoman Body. All then retire to the Yeoman Warders' Club, where the new warder is toasted by the Chief Yeoman Warder, who says, 'May you never die a Yeoman Warder'. This refers to the days when warders, if they retired, could sell their

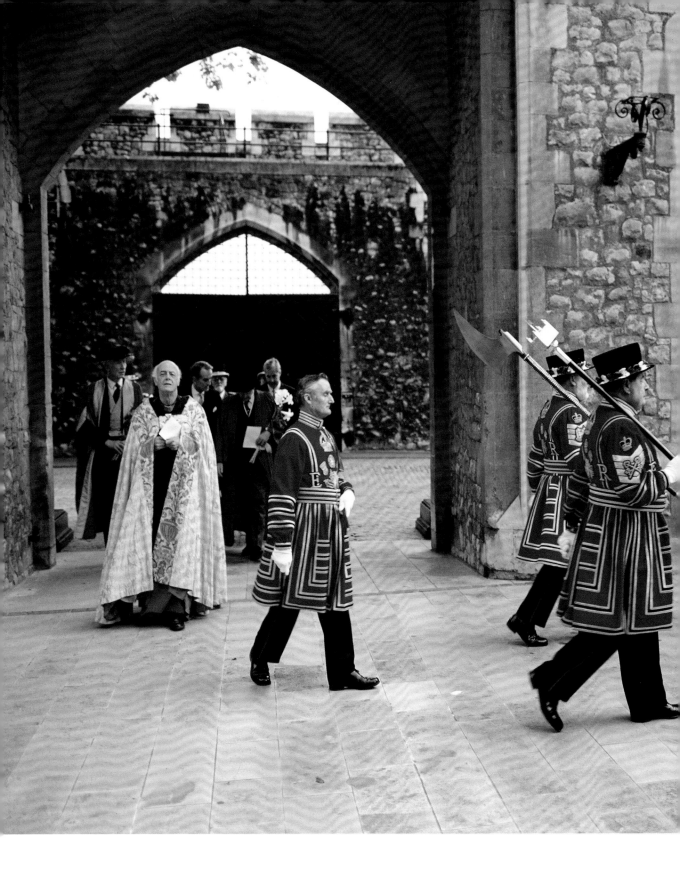

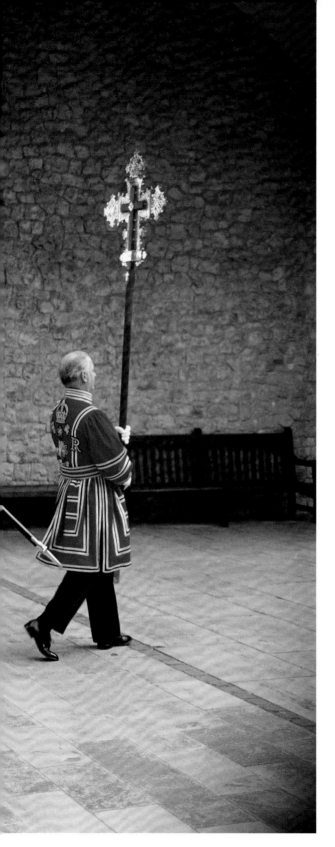

appointment for a tidy sum, and so recoup their own initial payment, whereas if they died in office, the vacancy would be sold by the Constable.

Constable's Dues

The Constable of the Tower used to be entitled to all sorts of perquisites. These included all cattle that fell off London Bridge, and swans which came below the bridge, as well as a toll of wine, oysters, mussels, cockles and rushes from ships entering the port of London. These latter dues were collected until the seventeenth century when the amount of boat traffic on the Thames made the custom impractical to administer.

The ship 'due' is one which the Tower has decided to revive in conjunction with the Royal Navy, to symbolize these ancient rights. Sailors from the ship concerned deliver a rum barrel to the Governor on Tower Green. The ceremony takes place, about once every nine months, whenever a large Royal Navy ship, of frigate size or above, visits the port of London, and the public are welcome to watch the event.

OVERLEAF *Constable's Dues*

Procession preceding the Ceremony of the Lilies and Roses

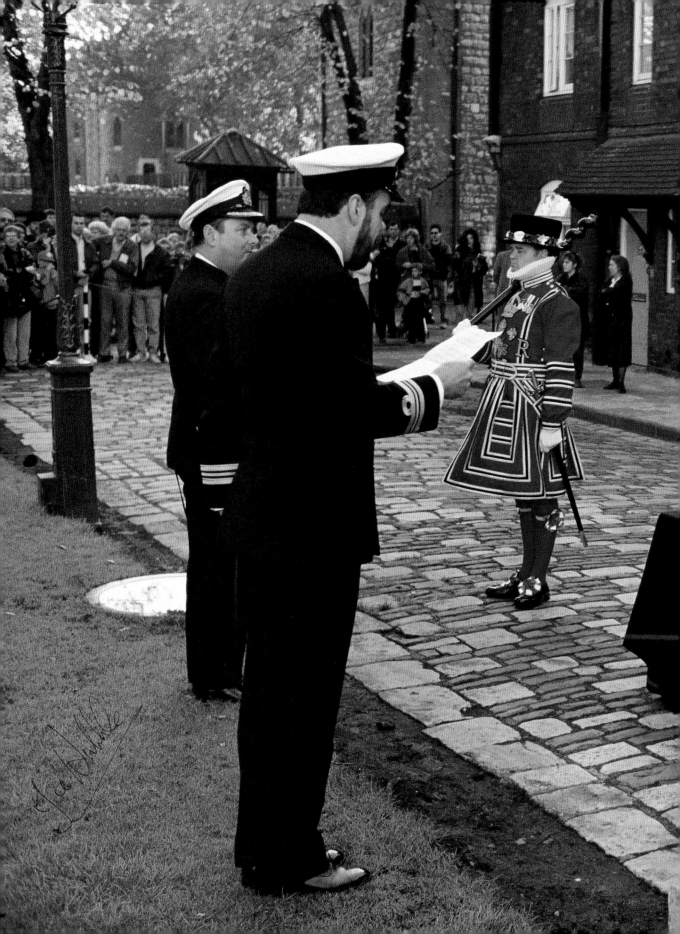

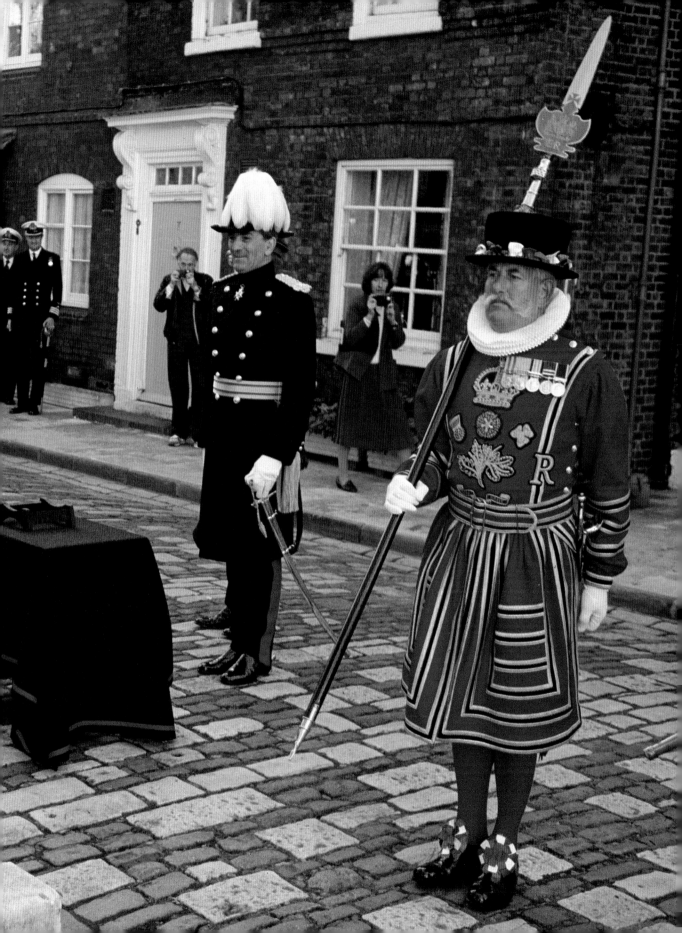

Beating the Bounds

In the past, when maps were scarce, and people illiterate, the Tower boundaries were marked by special stones. Traditionally, perambulations

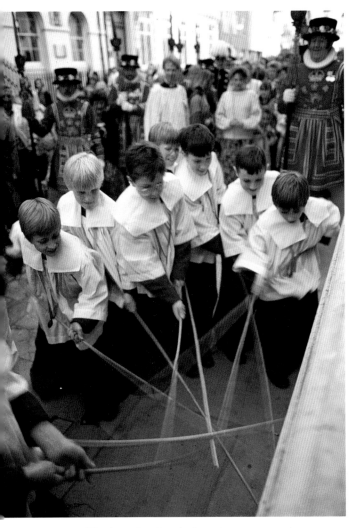

Choristers beating the bounds

were made to inspect the markers, and the location is said to have been impressed on the minds of local boys by beating them at each spot. The ceremony continues to this day, though in a modified form; it is the boundary markers which are beaten by the boys, not the boys themselves. The event takes place on Ascension Day every three years. A procession of Tower officers, the Chaplain, residents and local choristers led by the Chief Yeoman Warder carrying the mace, leave the Tower by the West Gate at about 6.30pm, and via the markers on Tower Hill and Trinity Square, return through the East Gate. Members of the public are free to witness the event, and may be forced to when traffic is brought to a halt as the procession passes.

Installation of the Constable

A new Constable is appointed every five years and the installation ceremony takes place on Tower Green, with much pomp and ceremony, including military band and trumpeters. Special seating is provided for invited guests, and troops representing regiments connected with the Constable (since 1784 always a senior military officer) are present.

The ceremony goes back to 1707 (although the office of Constable dates back to the eleventh century). In essence, the Lord Chamberlain, as the monarch's representative, hands the Constable the gold keys to the Tower, as symbol of his custodianship. Then the Constable, who does not live in the Tower, hands the keys to the Queen's House to the Governor, who is responsible for the day to day running of the Tower.

Tower Calendar

February 6
Anniversary of Queen's accession to the throne.
Gun salute 1pm.

Easter Sunday
State Parade and Church Service.

April 21
Anniversary of Queen's Birthday. Gun salute 1pm.

Ascension Day (May) (every 3 years – 1993, 1996)
Beating the Bounds. 6.30pm.

Whit Sunday
State Parade and Church Service.

May 19
Anne Boleyn's Memorial.

May 21
Ceremony of the Lilies and Roses.

June 2
Anniversary of Queen's coronation. Gun salute 1pm.

June 10
Anniversary of Duke of Edinburgh's Birthday.
Gun salute 1pm.

June (1st or 2nd Saturday)
Queen's Official Birthday. Gun salute 1pm.

August 4
Anniversary of Queen Mother's Birthday. Gun salute 1pm.

October (variable date)
State Opening of Parliament. Gun salute 1pm.

Sunday before Christmas
State Parade and Church Service.

Plus

Daily
Ceremony of the Keys. 10pm.

Daily
Changing the Guard, Tower Green. 11.30am (summer schedule*). Every alternate day in winter.* Cancelled in inclement weather.

Every 5 years (e.g. 1995)
Installation of the Constable.

Other variables include state visits, royal births and Constable's Dues.

Opening hours are
March–October, Mon–Sat 9.30–17.00
Sunday 14.00–17.00
November–February, Mon–Sat 9.30–16.00
Sunday Closed

Holy Communion in the Chapel of St Peter is at 9.15am and Matins at 11.00am.

*The summer schedule is March to October and the winter schedule is November to February. The Tower is closed on 24, 25, 26 December, 1 January, and Good Friday.

Things to See, Discover and Photograph

During the time I have spent at the Tower as a photographer, I have found numerous interesting things to see and photograph, inside and out, at different times of day, and in different weather conditions. Not all the subjects listed are suitable for photography, but where applicable I have given some tips to achieve good results. Some general points are worth mentioning: tripods are allowed at the Tower for amateur use, on the understanding that when used they do not hamper the passage of other visitors or create any kind of hazard. For those wishing to photograph exhibits in glass cases, there is a choice: either use a tripod and a long exposure time so that flash is not needed, or take the photograph at an angle to the glass so that the flash will not reflect back towards the camera. Subjects on the Tower perimeters are given first, followed by those inside the Tower.

Roman wall, Tower Hill: this is near the Underground station so don't miss it in your haste to reach the Tower. The wall is Roman for the first ten feet and thereafter is a medieval addition, giving a total height of about twenty-five feet. The statue has nothing to do with Roman London and is a nineteenth-century copy from two ancient originals – the body of Augustus with the head of Trajan!

Flemish cannon, inner ward

Tower Liberties: the boundary stones around the outside of the Tower are fun to look for (like the ordnance benchmarks inside the Tower). But don't go counting them all or you will get run over trying to see which number is on the brass plate in the middle of the road on Tower Hill!

Execution site, Tower Hill: very close to Tower Hill Underground station, in Trinity Gardens, this is the site of the 112 public executions which took place between 1381 and 1747. The gardens make a pleasant place for a picnic lunch.

Moat: a path goes round the outer perimeter of the former moat (now filled in) and is the main route to the Tower from Tower Hill Underground station, and also leads to Tower Bridge. It is worth taking time over as it provides some unusual views of the outer wall and you can sometimes see Tower residents using the tennis courts or exercising their dogs on the grass.

The Wharf: worth visiting, with views of the postern gate from the Byward Tower, the Traitors' Gate and the ravens memorial in the moat between St Thomas's Tower and the middle drawbridge. Look out for the lampposts with the letters BP. For a long time it was thought these had been given to the Tower by Queen Victoria and that the letters stood for Buckingham Palace. The truth is somewhat more prosaic: they stand for the

The Wharf and Tower Bridge, morning

Borough of Paddington, but no one knows how the lamps ended up here.

Tower Bridge: Tower Wharf is a good place from which to take a photograph of the bridge, in the afternoon when the sun is in the west (or from St Katherine's Dock in the morning). Notice a metal plaque about the opening of the bridge, set in the wall underneath it. Once on the bridge, you can either pay to enter, or take photographs at odd angles of particular features of the bridge.

Park, south of the Thames: this is on the south bank of the Thames, next to Tower Bridge. It provides an excellent view of the Tower itself, including part of Tower Bridge, and the best time for this shot is low tide. The park is also a pleasant place for a picnic.

Boy with Dolpin sculpture, Tower Bridge beyond

OVERLEAF *Tower Bridge by night*

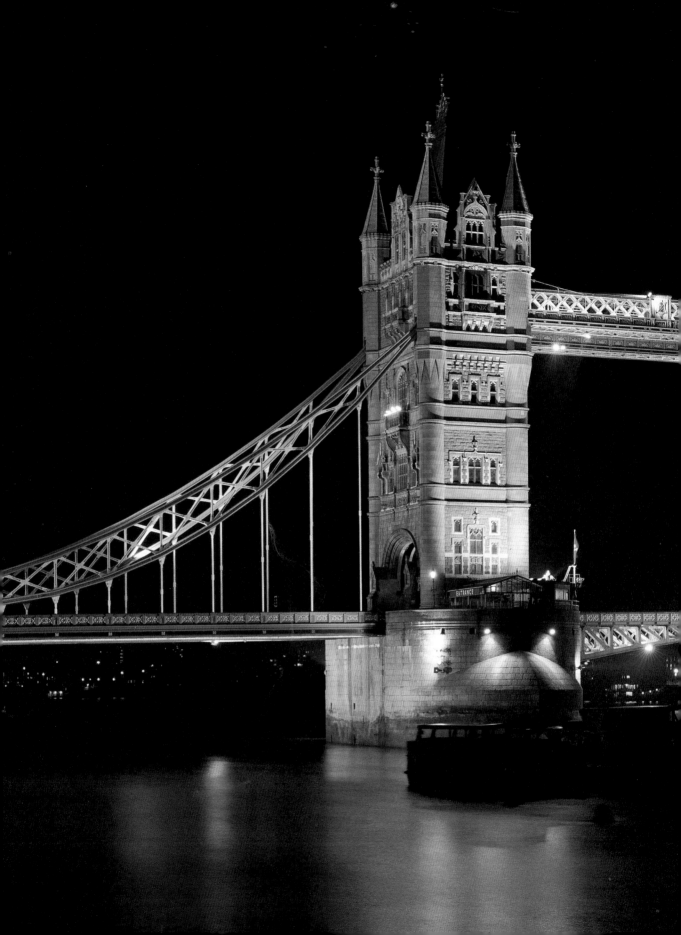

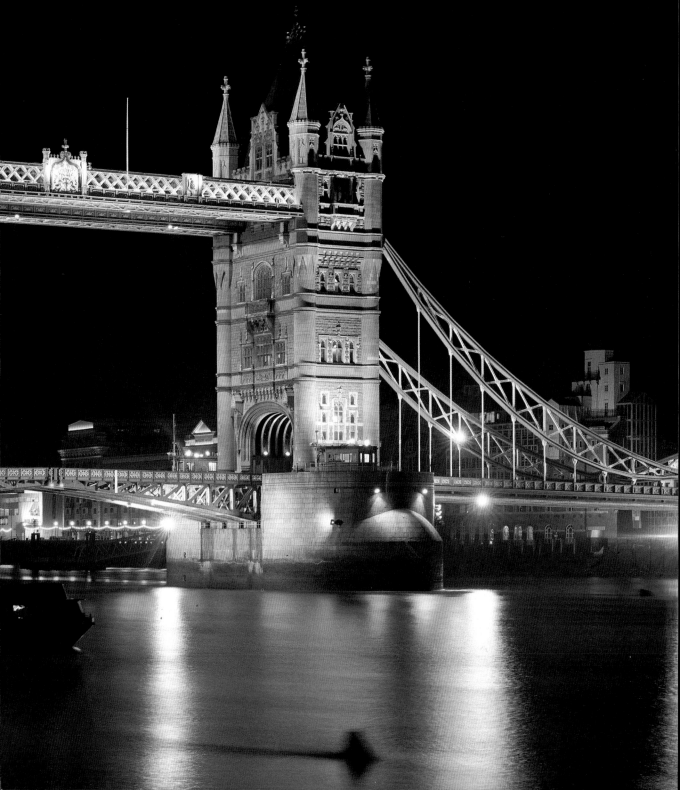

Water Lane: there are good views through the arches to the White Tower. Worth noticing is the timbered rear of the Byward Tower, dating from Henry VIII's reign. Look out for the mooring ring on the wall near the Bloody Tower; this dates from the time when this entrance was a watergate and the ring was used for securing boats.

Traitors' Gate: you will probably want to record this tragic place, but don't forget (if your camera allows it) to 'open up' a bit i.e. overexpose the picture by a little, as the detail is all in open shade. Otherwise the results will be too dark, especially as sun will be shining through the bars of the gate most of the time.

Wall Walk: this is the only opportunity for you to gain a bit more height to view things. One of the best places from which to photograph the White Tower is outside the staircase from the Wakefield Tower. To the south there are good views of the Wharf and Tower Bridge.

View of cannons from the Wall Walk

Traitors' Gate

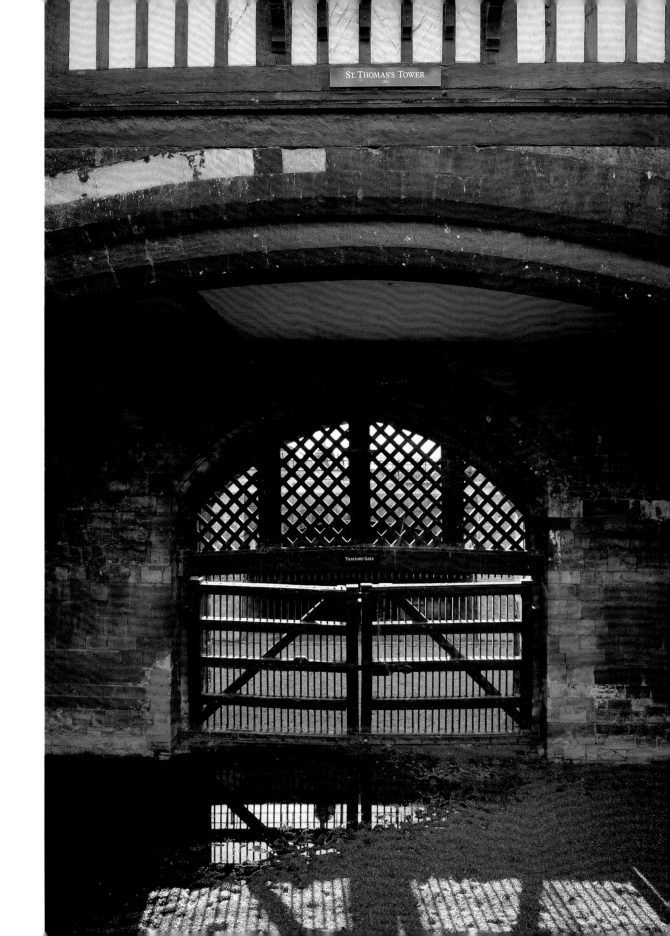

Tower Green: the public are not allowed to walk around the Green on the side of the buildings, but nonetheless you can take some good photographs of them, particularly the Queen's House, a well-preserved Tudor building. If you go to the Yeoman's box by the Bloody Tower you can photograph the buildings and get a picture of a friend standing next to the Yeoman. Generally, the warders like to be asked first.

In the nineteenth century, when Tower Green was cobbled, a path was laid in the stones in direct line from the Queen's House to the then south-facing entrance of the Chapel of St Peter ad Vincula. The door was closed up as part of the renovations to the chapel (see p. 27) in Victoria's reign, but remains of the path can be seen in the paving. Also worth looking out for is the freemasons' sign of the square and compasses set in the cobbles on the west side of Tower Green, just south of the Beauchamp Tower. It is in a private, chained-off area, near the houses adjacent to the Queen's House, but is discernable from the public path. Why this symbol was placed there is not known; it could be to indicate that the Yeoman Gaoler, who lived in one of the nearby houses, was a freemason. On the other hand, the square and compasses are instruments of the stonemason, so perhaps the craftsman was leaving his own mark.

Execution site, Tower Green: Yeoman Warders are usually patient enough to allow visitors to take photographs of each other with their heads on this block, although it simply marks the site where the temporary scaffold was erected for each of the six official executions on this spot. For a block actually used for an execution visit the Martin Tower.

Guardsmen: apart from the Changing of the Guard, these soldiers can be photographed at their

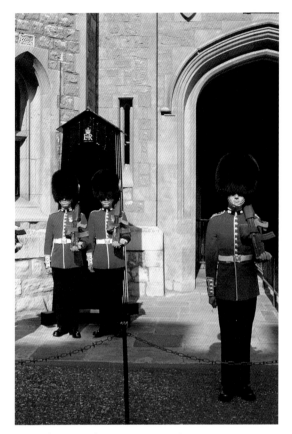

Grenadier Guardsmen preparing for guard change

sentry boxes. The one in front of the Queen's House is out of bounds for a close-up shot so the sentry outside the Waterloo Block is the one most photographed by visitors. Do not ask him any questions because he is not allowed to speak on duty. And don't go behind the chain in front of him, as he will probably make a formal challenge. Beware, the bayonet at the end of the rifle is very sharp!

Ravens: these are not easy to photograph well but if you are quiet, gentle and slow, you should get

some good opportunities. Try getting them when they pose on the execution 'block' on Tower Green, one of the cannons, or the wall on Tower Green with the White Tower as backdrop. But be careful, they are powerful birds with a painful bite! Also look for the roll of ravens on the inside wall between the Wakefield Tower and the Gallery shop. It gives their place of origin and date of enrolment at the Tower.

Lampposts: there are some unusual ones at the Tower. See the lamps with a design of three gold cannons (the emblem of the Board of Ordnance, whose offices were at the Tower until 1855) within the bracket, and one in front of the New Armouries which is made from a cannon and doubles as a signpost. Once you begin to have an eye for things like these you will spot a lot more of the less obvious details at the Tower.

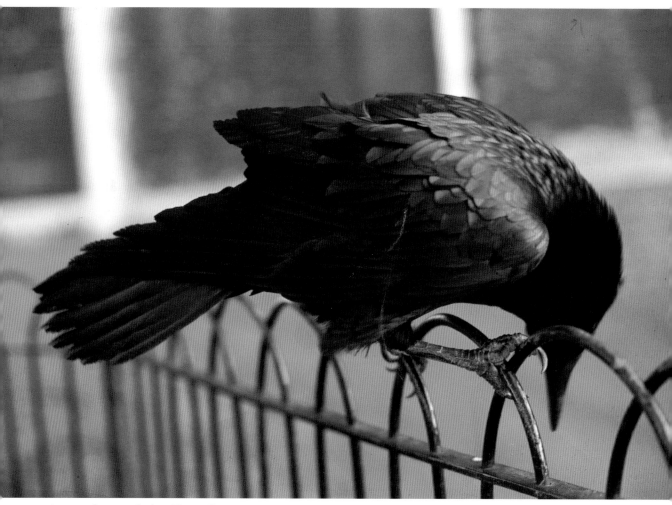

A raven photographed on Tower Green

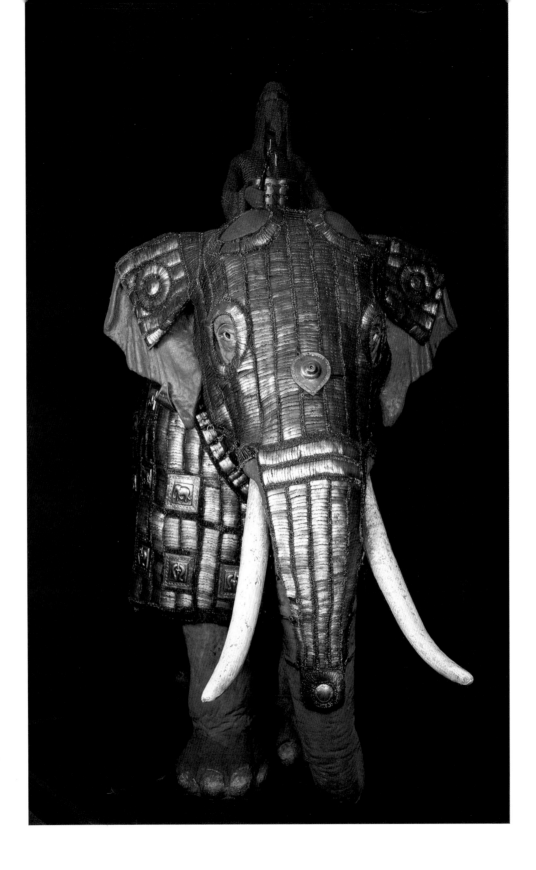

Flemish cannon, inner ward: the bronze gun dates from 1607, and the carriage from 1827. It is worth a photo in itself but is popular as a background to a personal shot. However, try and avoid a horizontal format as the barrel's length will make it appear to go through the person standing in front of it.

Turkish cannon, inner ward (by the Lanthorn Tower): Cast in 1530 and intended for the Turkish invasion of India, it was captured by the British at Aden in 1839. There is a story that when the cannon was being made, the local population donated their gold jewellery to strengthen the bronze. Believing this, it is said that someone cut a slice off the front of the cannon and melted it down to try and retrieve some of the gold.

Martin Tower: modern sundial set in the south wall of this tower.

Elephant armour, Oriental Armoury: on the ground floor of the Waterloo Block, this is a popular backdrop for a photograph, but visitors should be aware that the area is fairly dark and should move in close enough so that the flash covers the model elephant and mahout. The armour, probably the largest suit of armour ever made, is reputed to have been captured by Robert Clive at the Battle of Plassey in 1757, although there is no evidence to substantiate the claim.

Interiors: recommended interiors to visit are the Beauchamp Tower, Broad Arrow Tower, both chapels, Wakefield Tower, the White Tower, and, of course, the Jewel House. Photography (except in the Jewel House, where it is prohibited) need

Turkish cannon, inner ward

not be a problem, provided your camera has a built-in flash. But remember to be close enough to the subject to be within the covering power of the small flash (see the elephant armour, above), and when photographing anything behind glass, put the camera (gently) right against the glass, and hope for the best.

Elephant armour, Waterloo Block

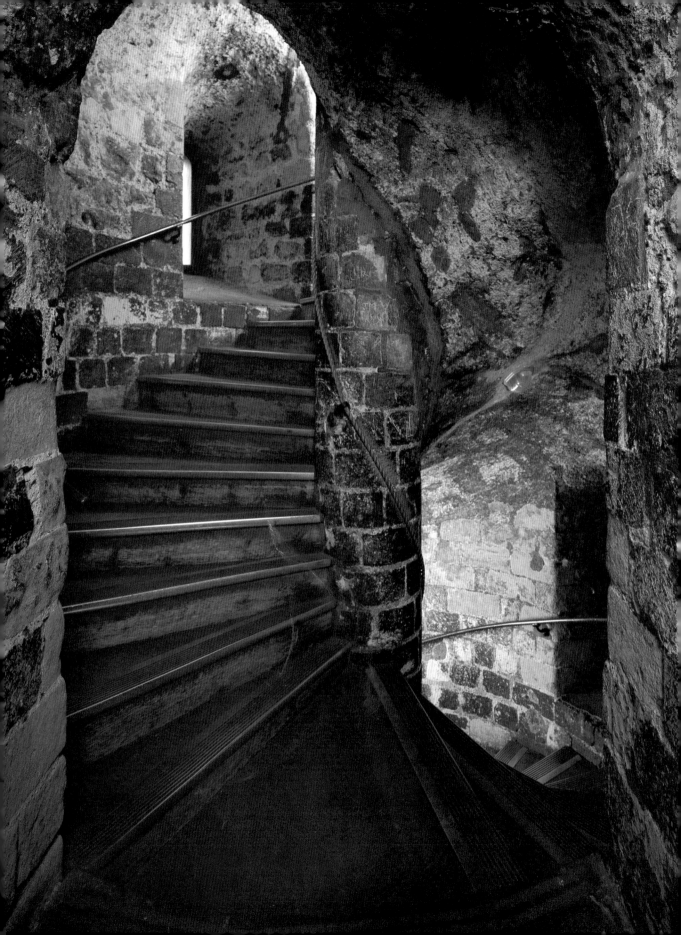

Yeoman Lore: Little-Known Facts and Stories

Many curious facts, stories and legends have accumulated during the Tower's nine-hundred-year history. Some are familiar from history books, others are unearthed only by careful study and some, told only on request by the few who know, are clearly subject to embellishment by 'verbal tradition'. It seems worth giving a few of the more interesting stories which are not always included in general histories of the Tower (though I would not be prepared to guarantee the accuracy of all of them!).

One long-serving Yeoman Warder claims that the reason William the Conqueror made one of the four towers in the White Tower round was not simply to accommodate the spiral staircase but because his druid, or wizard, had a room at the top and the circular stairwell would have provided no corners for the spells cast by other wizards to hide in.

Following her father's defeat by the English in 1306, the daughter of Robert the Bruce was brought from Scotland and imprisoned in a wicker cage hung outside the walls of the Tower. There she remained, alive, for many years, fed with scraps of food by kind passers by. She was later released, but never fully recovered from her ordeal although she returned to Scotland and even married.

Pollution was a problem in the City of London as far back as 1307: just before his death, Edward I outlawed the production of bricks near the Tower, because of the foul air coming from the kilns.

In 1546 William Foxley, a maker of melting pots at the Mint, is said to have fallen asleep on the job and slept for fourteen days. He continued to work at the Tower until his death in 1587.

The steps at Traitors' Gate are not the original ones. They are buried below Water Lane further back towards the gateway of the Bloody Tower.

Above Traitors' Gate there is a pair of gates in the trellis-work. These were for use at high tide when the main gates were submerged.

From the sixteenth to mid nineteenth centuries the Tower's water supply was drawn from the Thames. A mill in the basin below St Thomas's Tower pumped the water into lead cisterns on top of the White Tower. In 1805 a hydraulic steam engine was installed in the same place, but in 1862 its vibrations caused part of the southeast turret of St Thomas's Tower to collapse. A new pump house was then built on the site of the Lion Gate, a building now used by the West Gate shop.

Spiral stairs, White Tower

Sir John Barkstead, goldsmith and Lieutenant of the Tower (1652–60), was thought to have hidden a large amount of money (some say £20,000 in coins), somewhere in the Tower before his arrest and execution early in Charles II's reign. The diarist Samuel Pepys took part in several searches for the money, probably in the Lower Bell Tower. Excavations there in 1958 revealed a hole filled with wine bottles, possibly placed there by the disappointed treasure hunters. Further attempts have been made to find the gold by enthusiastic Governors, but 'Barkstead's Treasure' has never been discovered.

In 1679, the Yeoman Body commissioned Joseph Windmills, a member of the Worshipful Company of Clockmakers, to make a grandfather clock for the Warders' Hall. A particular feature of the clock, which is now in the Yeoman Warders' Club, is the extra mark at $6\frac{1}{2}$ minutes to the hour. When the hand reached that point the warders knew it was time to leave for the Ceremony of the Keys. For many years new warders were expected to pay five shillings (twenty-five pence) 'clock money' to help pay for the clock, but the practice continued for so many years that the clock must have been paid for several times over.

In the eighteenth century young ladies wishing to conceive would stick a pin in the large codpiece of Henry VIII's 1540 foot armour. The Archbishop of Canterbury eventually stopped the practice.

There is a large slab of black marble set into the ground by the southwest corner of the Chapel of St Peter ad Vincula. Thousands of visitors pass over it on their way to the chapel, but the stone is conspicuous in having no lettering or marker of any kind. Here lie three soldiers of Lord Sempil's regiment, shot on Tower Green on 19 July 1743

for mutiny. Over a hundred fellow soldiers, also found guilty, but reprieved, witnessed the event.

During the nineteenth century the Tower had its own school for children of those who worked in the Tower. It had premises in the casemates immediately south of the Brass Mount.

For the duration of World War II the Crown Jewels were removed from the Tower, and it has never been revealed where they were hidden.

During World War II three-quarters of all US troops stationed in Britain visited the Tower as a propaganda exercise.

The chair in which Josef Jacobs sat for his execution as a spy in 1941 (he had an injured knee which prevented him from standing) is preserved in the Tower, but is not on public display.

The German Ambassador to Iceland was held in the Tower during World War II.

Rudolf Hess's autograph is on a piece of Tower stationery framed in the Yeoman Warders' Club. The room in the Queen's House in which Hess was kept in 1941 faces east over Tower Green. It is on the first floor, with a three-bayed Tudor window, above a blue door.

The flag which in summer flies from the White Tower is the largest Union flag to fly from a public building in the United Kingdom. The flagpole, 26 metres high (85 feet), was made from a Douglas fir tree, originally 56 metres high (185 feet), and was presented in 1948 by the Boy Scouts of British Columbia.

If you look closely at the gold ball on top of the Bell Tower, you will see that a small spike appears to project from it. A Yeoman Warder told me that in 1965, when the commemorative Churchill

The room in the Queen's House occupied by Rudolf Hess in May 1941 is situated directly above the blue door.

The longest-serving Jewel House Warden in 1990 was Senior Warden Richardson. A conservative estimate of the number of people who, in his eighteen years' service, have walked past him close enough to shake his hand is 40 to 50 million – almost equal to the population of the British Isles!

The Tower of London has been designated a World Heritage Site by UNESCO, acknowledging its worldwide importance.

The Royal Armouries has a workshop at the Tower, which maintains and repairs its large collection of arms and armour. It will identify and value pieces of armour belonging to the general

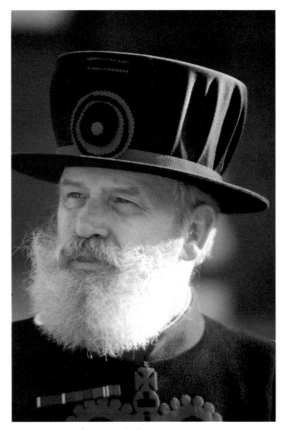

Yeoman Warder Ramshall

crown was minted, the Clerk of the Works for the Tower, a Mr Robinson, decided to set one of these five-shilling pieces into the ball. (Another Yeoman Warder has told me, however, that it is a gold sovereign, a third that it is a 50p piece, and a fourth that there is nothing there at all!)

NASA scientists designing space suits for the early astronauts came to the Tower Armouries to examine the remarkable flexibility of the joints in sixteenth-century body armour.

public. The Armouries also sell reproduction suits of armour. A fibreglass copy of Henry VIII's 1540 foot armour costs more than £3500.

It would be surprising if there had been no reports of ghosts at the Tower considering its colourful past. Over the years there have been tales of shapeless white forms, headless figures and mysterious footsteps, seen or heard at difference places in the Tower. In 1864, a rifleman who had been on sentry duty one night outside the Queen's House, was court-martialled for neglecting his post after he was found unconscious on the ground. In defence he argued that he had been approached by a white figure. His three challenges had received no reply, so he charged with his bayonet, only to go right through the figure. Whereupon he had fainted. Two witnesses had seen the whole incident (including the white figure) from a window in the Bloody Tower, and on the basis of this corroboratory evidence, the soldier was acquitted.

In World War I a sentry on duty at the West Gate turned out the Guard because he saw a procession coming down Tower Hill, consisting of two men carrying a stretcher, followed by three men in long black gowns. When challenged, they did not halt but went past him into the Tower. On the stretcher he saw a severed head lying next to the headless body. The procession tallied exactly with the historical sequence of events after an execution on Tower Hill. The sentry witnessed the same event on several subsequent occasions.

In Victorian times Harrison Ainsworth's novel *The Tower of London* (1840) was widely read

Ghostly visitor (B. Ramamrutham)

and admired, and contributed to an exaggerated concentration on the Tower's gruesome past in the nineteenth century. More recently, the well-known comedian Stanley Holloway sang a spooky song entitled 'With her head tucked underneath her arm', about Anne Boleyn's ghost, which tells of her walking the Bloody Tower.

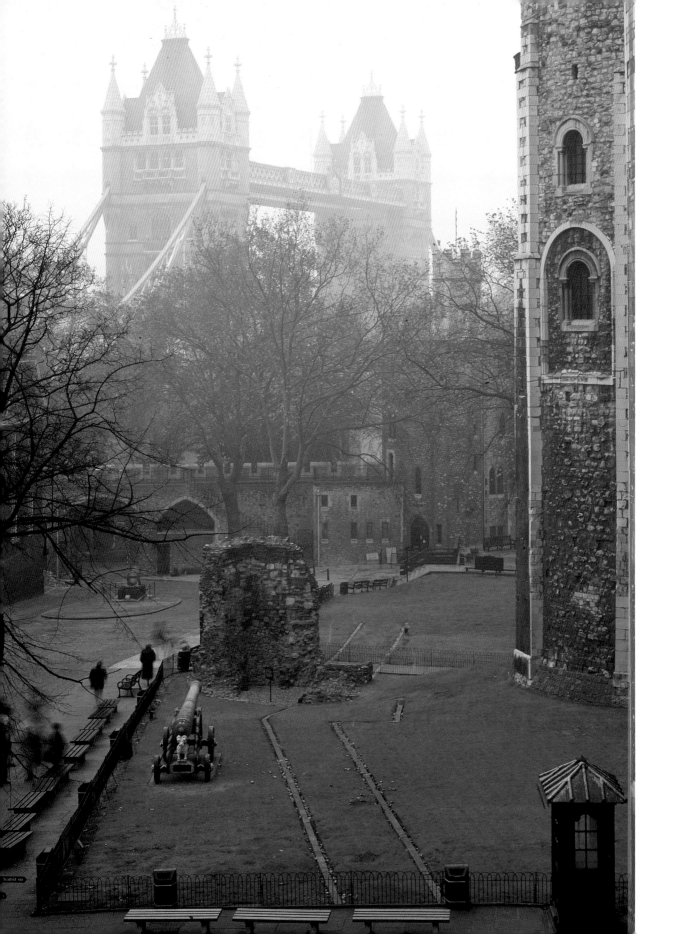

Scaffold site

A Short History of the Tower

by Julia MacKenzie

Origins

The centrepiece of the present Tower of London is the White Tower, the Norman keep begun by William the Conqueror about 1078. This was not the first fortification on the site, however, because the Normans had built a wooden fort here, nestled between the Roman city wall on the east and the river wall to the south, soon after their conquest in 1066. This was matched by two forts at the western end of the city: Baynard's Castle and Montfichet's Tower, just south of Ludgate Hill. The importance of the Tower of London site is shown by the decision to build a permanent fortress here, rather than at the west end: it would not only dominate the city but control the river and access to and from the sea. For, although the Normans had conquered, they still had to impose their rule on an indigenous population which outnumbered them, and protect their new possession from aggressors such as the Danes.

The castle keep had a dual function: as a military fortress and as residence for the ruler. The tower was defended on two sides by the Roman defences, but on the city side to north and west a new wall was erected. London's power was such that in 1097 the Anglo-Saxon chronicle commented that 'men from many shires in fulfilling their labour service to the city of London were oppressed in building the wall around the Tower'.

As well as being a palace fortress, some of the Tower's later functions date from these early years. It seems possible that William the Conqueror and his successors kept some treasures in the sub-crypt, a harbinger of the Tower's future use as guardian of the Crown Jewels.

The Tower was also used as a state prison, but no part of it was ever built specifically for this use. The White Tower was barely finished when in 1100 it received its first prisoner: Ranulf Flambard, Bishop of Durham and chief minister to William II. Typical of so many to follow him, Flambard was imprisoned by a new king, Henry I, anxious to distance himself from the unpopular policies of his predecessor. However, in honour of his rank, Flambard's imprisonment was far from uncomfortable. Accommodated on the first floor of the tower, he was entitled to visits from his friends and generally lived well. As with so many future prisoners, he used his own means to improve his standard of living in the Tower, and to engineer his escape. Having given a banquet for his guards, which rendered them senseless, he climbed out of a window and down a rope smuggled to him in a wine cask. He fled to Normandy but was later pardoned by the King and restored to his See.

The line of the Roman city wall, inner ward

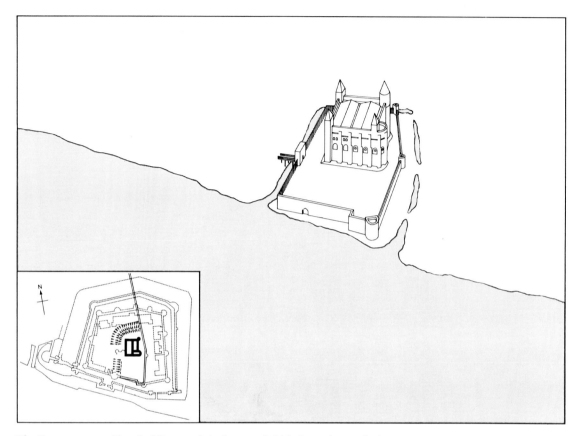

The Tower c. 1100. New building work is shown solid black on the small plans

One other precedent was set in these early years: the jurisdiction of Tower authorities over areas beyond the Tower walls. In the Norman period the Constable of the Tower had rights in the Jewry, or Jewish quarter, home of some 1000 Jews who had been brought over by the Normans to provide revenue by taxation, confiscation and money lending, but these unpopular activities meant that they needed Crown protection, and would take refuge in the Tower. They would also abuse their privileges and be held captive in the Tower. It was the Constable's role, acting on a mandate from the Justices of the Jews, to deal with any offences within the Jewish quarter, whether perpetrated by Jew or Christian. This relationship between the Tower and the Jews ceased upon their expulsion from England in 1290.

Middle Ages

William's castle remained without much change for a hundred years . The Wardrobe Tower dates from the late twelfth century and it seems likely that before 1200 the wooden staircase at the entrance to the White Tower was replaced by a covered stone one. More extensive modifications

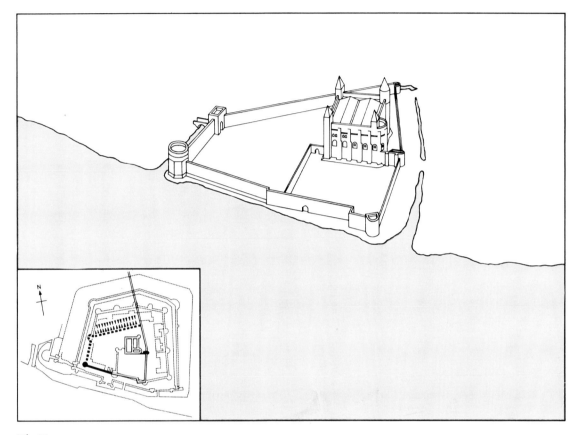

The Tower c. 1200

were undertaken at the end of the twelfth century, by William Longchamp, Bishop of Ely, Constable of the Tower, and Richard I's Chancellor, an extremely powerful position in view of the King's long absences abroad at the Crusades. Longchamp was unpopular: 'the laity found him more than a king, the clergy more than a pope, and both an intolerable tyrant'. As defence against the barons and the King's brother, Prince John, Longchamp built the riverside wall from the site of the later Bloody Tower to the Bell Tower, also probably built by him. It is possible he also constructed a western curtain wall northward to the present

Beauchamp Tower, thus making an outer ward which almost doubled the extent of the castle. Beyond the western wall Longchamp dug a ditch which he intended to flood with Thames water, but the experiment failed, and when Prince John laid siege to the Tower in 1191, Longchamp surrended within three days and fled abroad.

John's successors, Henry III (1216–72) and Edward I (1272–1307) turned the Tower of London into the great concentric fortress we know today. Henry's additions began even during his minority, with work beginning about 1220 on the Wakefield Tower (then called the Blundeville

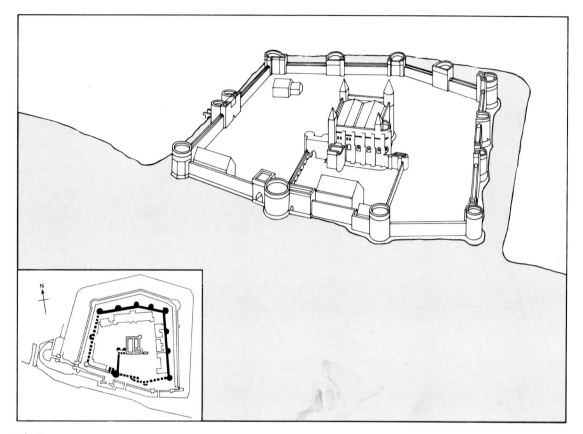

The Tower c. 1270

Tower) and the Lanthorn Tower, and a new
curtain wall between them. These two towers
were in the southern corners of the now inner
bailey and abutted straight onto the river.

The Wakefield Tower contained the King's
private apartments, complete with oratory on the
upper floor, and a postern gate just to the east of
the tower gave him direct access from the river.
The river, then and for hundreds of years to come,
provided the safest and most convenient access to

Henry III's wall of the inner ward

the Tower. At the same time Henry was adding
to the palace at Westminster, begun before the
Norman conquest by Edward the Confessor. This
was to be the main administrative centre of the
kingdom while the Tower was more of a refuge
and power base to withdraw to in time of trouble.

A watergate was provided for non-royal visitors
to the west of the Wakefield Tower, and this
was subsequently incorporated into the Bloody
Tower. Security for the inner ward was provided
by the Coldharbour Gate (only the foundations
remain today), near the main entrance to the
White Tower. With the inner bailey thus

protected, new accommodation could be built and existing buildings renewed. By 1234 the great hall was rebuilt along the inner curtain wall next to the Wakefield Tower (near the site of the present Gallery shop) and a new kitchen erected. Henry was also concerned with the physical appearance of the buildings. The whitewashing of the White Tower dates from 1240, while at the same time the lead drainpipes were extended to ground level to avoid unsightly stains from rainwater. Internally, walls were also painted, windows were glazed and floors tiled.

Henry then began expanding the castle to the north, east and northwest with a new towered curtain wall and moat, including a major landgate on the site of the present Beauchamp Tower. These extensions were unpopular, part of the ever uneasy relationship with the City. To the east, where for the first time the Tower boundaries were extended beyond the old Roman city wall, £166 was paid in compensation in 1239 to the Prior of Holy Trinity, Master of St Katherine's Hospital, and others in the vicinity 'for the damage they sustained by the wall and ditch of the Tower of London'. This extension took in the church of St Peter ad Vincula, a local parish church, which was to become the chapel for the inhabitants of the Tower, while the King and Court continued to use the Chapel of St John in the White Tower.

In Henry's reign the royal menagerie was first housed at the Tower. Then, as now, monarchs would exchange gifts of state; in 1235 Henry received three leopards from the Emperor Frederick II, and in 1251 a polar bear was sent from Norway. Relations with the City can hardly have been improved by Henry ordering the sheriffs to pay fourpence a day for the upkeep of the bear; but it provided amusement for the local population who came to see it fishing in the Thames.

More crowds came in 1255 when Henry received an elephant from the King of France, said to be the first seen in England, and again the sheriffs had to pay, this time for a specially-built elephant house.

The Tower also became established in this period as storehouse for the King's riches. When Henry returned from France in 1230, he ordered the Bishop of Carlisle to replace the Crown Jewels in the Tower. This did not, however, guarantee their safety. In need of cash later in his reign, Henry took them to France and pawned them to a group of French merchants. They were subsequently redeemed and brought back for the coronation of Edward I in 1272. This was not the only time this would happen – in a period of expensive wars with France and domestic conflicts, such as Henry's with Simon de Montfort, pawning the family silver, as it were, was a speedy means of raising money.

Edward I (1272–1307) was a strong military leader interested in castle fortifications. He realized that the latest developments in weaponry made it imperative to extend the castle's defences. Within a decade, 1275–85, the Tower underwent its final large-scale architectural development, becoming the building which, in essence, we see today. Edward created a new line of outer defences. His father's moat was filled in, and land gained from the river to the south, to form an outer ward. A low stone outer wall was constructed, over which archers and cross-bowmen could shoot from the inner wall, and beyond a new moat. A new western landward entrance was created, Henry's landgate being replaced by the Beauchamp Tower. The new

Water Lane by the Wakefield Tower

approach to the Tower had an outer barbican (later called the Lion Tower), a middle tower (today's entrance) and the Byward Tower. To the south, the impressive engineering feat of reclaiming land from the river meant the old 'Bloody' watergate became the only gate between the outer and inner wards, while a new watergate was constructed on the river – St Thomas's Tower. It seems that Edward I had his private apartments here, and a bridge was built connecting the new tower with the other royal apartments.

The Tower had been a war store from about 1200, its location convenient for the Continent and the interminable wars with France. Arms were made and stored here, new supplies brought in in time of war by sheriffs and mayors, and captured

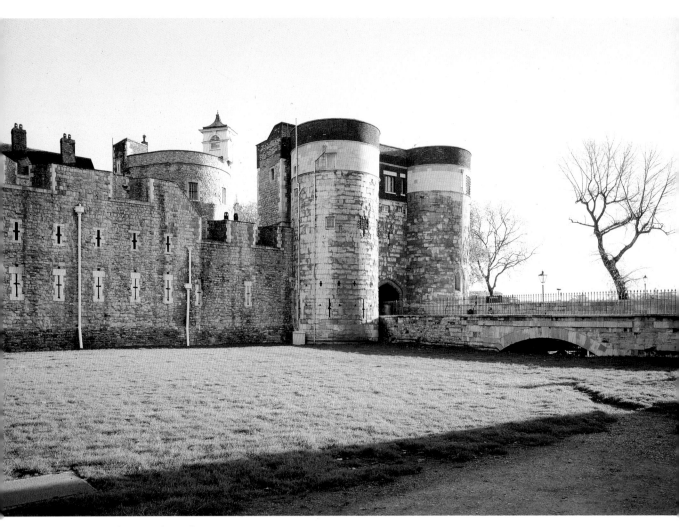

Byward Tower from the moat

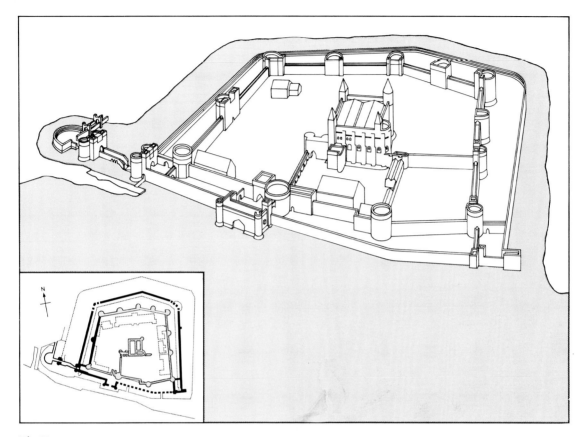

The Tower c.1300

enemy weapons brought back here. The official post of King's Smith can be traced back as far as Edward's reign – to 1275, and in the early part of the following century gunpowder was manufactured in the Tower. The use of the Tower as depository of state records dates from Edward's reign as does the presence of the Mint.

Edward III (1327–77), like his great-grandfather Henry III, was a patron of the arts and a keen builder. In addition, he won notable victories at Crécy (1346) and Poitiers (1356), and the Tower played its part as an arsenal. The French King John, captured at Poitiers, was accommodated in the original state apartments in the White Tower and King David II of Scotland was also a prisoner for a time.

Edward III undertook repairs and new building at the Tower, sometimes personally supervising the work. It may have been in this period that a new staircase was put in the south wall of the White Tower, at first-floor level, giving access from the outside apartments to the chapel on the second floor (and used by visitors to the chapel today). The 'Bloody' gateway was improved and the King's own apartments were moved to, or near, the Lanthorn Tower with access via a new

postern and watergate (Cradle Tower). In addition Tower Wharf was constructed in stone between the moat and river, as far east as St Thomas's Tower.

Edward was succeeded by his grandson, Richard II (1377–99), a minor, whose uncle, the old King's brother, John of Gaunt, acted as regent. It was Richard, as a ten-year-old, who established

Lanthorn Tower from Water Lane

the precedent of the monarch staying in the Tower for a few days before his coronation and processing from there through the City to Westminster to be crowned, a custom followed by most of his successors in the next 300 years. But the enthusiasm which greeted the young King soon turned to discontent. When attempts were made to raise a poll or 'head' tax to pay for the wars with France, rebels from Kent and Essex under Wat Tyler marched on London and the King and Court took refuge in the Tower. After burning John of Gaunt's palace of the Savoy west of the City, the rebels camped for the night on Tower Hill. To avoid the prospect of any kind of siege, the King agreed to meet the rebels at Mile End. In his absence a group of rebels entered the Tower, possibly with connivance from inside, although it was perhaps difficult for the garrison to resist knowing the King was effectively held hostage. The intruders stole armour and weapons from the privy wardrobe stores, invaded the royal bedchamber, 'attempting familiarities with the Princess of Wales' (the King's mother), and finally discovered the hated Treasurer Robert Hales and Simon of Sudbury, Lord Chancellor and Archbishop of Canterbury, perpetrators of the poll tax, at prayer in the Chapel of St John. With two companions, they were dragged out to Tower Hill and executed without delay, the first on that site. But it was not long before Wat Tyler's head replaced Simon of Sudbury's on a pole on London Bridge. At a meeting between the rebels and the King at Smithfield the following day, the Mayor of the City, William Walworth, killed Wat Tyler. The King bravely faced the remaining insurgents and asked: 'Sirs, will you shoot your king? I am your captain. I will be your leader. Let him who loves me follow me.' Richard's move was effective, but fatal for the rebels – 150 were arrested and executed.

Richard's subsequent problems centred on the nobility – during a period when they held the upper hand, the King's former tutor, Sir Simon Burley, was executed on Tower Hill in 1388, the first official execution to take place there. The King regained control, however, and nobles such as Thomas de Beauchamp, Earl of Warwick, were imprisoned in the Tower. The Treasury would make an allowance for the upkeep of prisoners, usually debited from their estates. The sum was dependent on their rank, as was the type of apartment. The Tower authorities would have received 40 shillings a week for Warwick, an earl, whereas a baron would have merited 20 shillings and a knight 10. Many prisoners improved their standard of living out of their own pockets.

Two years later Richard followed Warwick to the Tower. His increasingly despotic rule had made his cousin Henry Bolingbroke (son of John of Gaunt) an attractive alternative. Bolingbroke returned from ten years exile in 1399 and within a short time Richard was imprisoned in the White Tower and forced to abdicate. He was removed to Pontefract Castle and murdered in 1400. Richard's legacy to the fabric of the Tower was the extension of the Wharf to the east from St Thomas's Tower, thus terminating the use of the Cradle Tower as a watergate.

The new king, Henry IV, created forty-six Knights of the Bath on the eve of his coronation, in an unprecedented ritual. The bath had the symbolic significance of spiritual, as well as bodily cleanliness prior to receiving the knighthood. Each prospective knight had to wash in one of forty-six baths specially placed around the walls of an apartment in the White Tower. The King made the sign of the cross with water on the back of each knight-elect. An all-night vigil followed in the chapel, each knight kneeling in devotion before his armour.

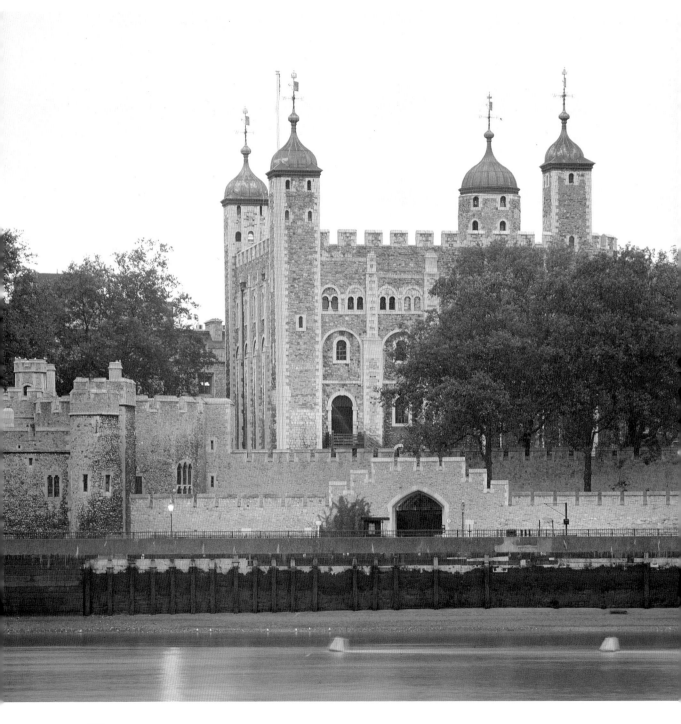

The Tower received a continuing supply of prisoners in the reigns of Henry IV and Henry V, due to battles with the Scots and Welsh, domestic conflict with barons and Lollard heretics, and war with France. Some proved lucrative for the royal coffers: a ransom of 50,000 livres was paid for the French King's nephew, Charles, Duke of Orleans, captured by Henry V at Agincourt in 1415, but only after an imprisonment, partly at the Tower, of twenty-five years.

Apart from maintenance there is no record of any building activity in the early fifteenth century. The war machine, however, necessitated the appointment in 1414 of Nicholas Merbury as 'Master of the works of the King's engines and guns and of the ordnance'.

Henry V's premature death in 1422 left the throne occupied by his nine-month-old son Henry VI, who proved, once grown up, ill-suited to the role of king. The weakness of the King and his advisors, combined with the military skill of Edward, Duke of York, led to the Wars of the Roses and a period of confusion, deceit and royal murder which resulted in the ascension to the throne of Henry Tudor, as Henry VII, in 1485.

In 1450 a popular uprising led by Jack Cade, marched on London from Kent. The King, after initial resistance, withdrew to Kenilworth. The rebels laid siege to the Tower and were rewarded when the Constable, also Lord Treasurer, Lord Say, was handed over to them, and was beheaded.

The Yorkists probably gave Cade covert support. By 1461, Edward had seized the crown and Henry had fled to Scotland. Four years later he found himself a prisoner in the Tower and a neighbour of his adversary, for Edward IV (1461–83) lived in the Tower more than any previous

The Tower in twilight from south of the river

monarch. He built the Bulwark beyond the Lion Gate to strengthen the defence of the Tower's landward entrance. Political conflict brought a steady stream of prisoners to the Tower and it was in Edward's reign that a permanent scaffold was erected on Tower Hill. Although Tower Hill was part of the Tower Liberties, Edward granted the City, from whom he needed support, the right to carry out executions there. Prisoners were handed over to the sheriffs at the Bulwark Gate and the remains (minus the head) handed back after the deed was done.

Henry VI briefly ruled again in 1470 thanks to a coup by Warwick 'the kingmaker', but it proved to be Henry's death sentence. Edward soon reclaimed the throne, defeated the Lancastrians at Barnet and Tewkesbury, and entered London on 21 May 1471. Henry was found dead in the oratory of the Wakefield Tower the next day. Officially he died 'of pure displeasure and melancholy' but a chronicler recorded that he was 'strykked with a dagger by the hands of the Duke of Gloucester' (the future Richard III). Henry's death was considered a necessary evil to protect the Yorkist line. Edward's determination to remove all threats to his security extended as far as his brother George, Duke of Clarence. He had plotted against the King and was secretly executed in February 1478, supposedly drowned in a butt of malmsey wine in the Bowyer Tower.

Edward's death five years later again left the throne in possession of a minor, his son Edward V, aged twelve. Edward IV's one remaining brother, Richard, Duke of Gloucester, was appointed Protector, and secured control of the young boy, placing him in the Tower, preparatory to the coronation. To secure his position, at a council meeting in the White Tower in June 1483, Richard arranged for the arrest of four council members. One of them, the Lord Chamberlain, William Has-

tings, was immediately executed for treason on Tower Green, his head resting on a timber log, hastily found for the purpose – the first, and least ceremonious of the seven executions on that spot.

Events moved quickly following this illegal act. Richard persuaded the King's mother to send Richard of York to keep his brother company in the Tower; they were subsequently declared illegitimate and Richard claimed the throne as the rightful heir, and was crowned on 6 July, 1483.

What happened to the two princes remains a mystery to this day. A contemporary account by an Italian, Dominici Mancini, recounts how, after the death of Hastings, the boys 'were withdrawn into the inner apartments of the Tower proper [the White Tower probably], and day by day began to be seen more rarely behind the bars and windows, till at length they ceased to appear altogether'. According to Sir Thomas More, who investigated the matter some forty years later, Richard ordered the Constable of the Tower, Sir Robert Brackenbury to hand the keys to Sir James Tyrell for one night. Tyrell's accomplices, John Dighton, his groom, and Miles Forrest, one of the princes' guards, are said to have killed the boys. It is thought a priest removed the bodies from near the Wakefield Tower and placed them under the stair (see p. 109) leading from the palace apartments to the Chapel of St John, thus placing them as near consecrated ground as he could manage. When the buildings along the south front of the White Tower were demolished in 1674, in the reign of Charles II, the skeletons of two children were discovered in a wooden chest. Then, and when re-examined in 1933, the bones were declared to be the correct age and size for the two boys. Charles had them interred in Westminster Abbey.

Richard, obtaining the crown in such dubious circumstances, never fully established his hold on the throne. The opposition rallied around Henry

Tudor, a descendent of Edward II, and two years later Richard lay dead at Bosworth Field.

The Tudors and Stuarts

In Henry VII's reign the Tower played host to the various rivals and pretenders to the throne. Henry married one of the claimants – Elizabeth of York, the sister of the 'Princes in the Tower' – and she spent the night before her coronation at the Tower. It was also to be the scene of her lying in state, after her death in childbirth, in 1503. Her cousin, the Earl of Warwick, was held in the Tower as a possible threat to the Tudor King. He was executed on Tower Hill in 1499. As A.L. Rowse has written, 'one way or another, the Tower was fatal to Yorkists'.

Henry's reform of the currency also kept the Mint busy, in the area between the inner and outer walls. There were great festivities when Catherine of Aragon was received at the Tower, prior to her marriage there to Arthur, Prince of Wales. This was so important a diplomatic success that when Arthur died five months later, the Spanish princess was betrothed to his younger brother Henry, with revolutionary repercussions that would usher in the Tower's most famous and savage period.

Catherine's failure to produce a male heir became an increasing cause for concern. Henry VIII's desire for a male heir was to dominate much of his reign. Queens and ministers fell from grace, and the impossible became possible. Never had a queen consort been divorced, never had one been executed. Henry managed to do both, twice. Henry's divorce from Catherine resulted in the break between the Church of England and the Church of Rome and the creation of Henry as the Supreme Head of the English Church. Henry's Lord Chancellor, Thomas More and John Fisher, Bishop of Rochester both refused to accept this –

and paid with their lives. They were imprisoned in the Bell Tower and executed on Tower Hill within two weeks of each other in 1535.

Within a year they were joined in the Chapel of St Peter ad Vincula by Anne Boleyn. In her three-year reign she had produced only a daughter, the future Elizabeth I. Henry had grown tired of her, and having got rid of one queen, the precedent was set for disposing of another. Anne was imprisoned on trumped-up charges of adultery, and by tradition spent her final days in a room in the Queen's House (built in Henry's reign and known then as the Lieutenant's Lodgings). Anne was the first consort of a reigning king to be beheaded; the first of only five women to be beheaded for treason (the others all died on the same spot within twenty years of her); the first person to be executed on a scaffold on Tower Green, in deference to her sex and position, and instead of the axe she was beheaded, at her own request, with a sword, a Frenchman being brought from Calais especially to perform the task. This was perhaps a wise move as the axe was rather a clumsy weapon and did not always decapitate the prisoner at the first blow. Nonetheless, aristocratic prisoners were lucky to avoid the punishment given to ordinary folk – they were hanged, drawn and quartered. Those executed on Tower Green had a further privilege: they were buried with their heads, whereas those beheaded on Tower Hill had their heads placed upon a spike in some prominent place, usually London Bridge.

Anne's fate was shared by her cousin, and Henry's fifth wife, Katherine Howard, who with her lady in waiting, was executed in February 1542. Katherine is said to have asked for the block to be brought to her apartment the night before her execution in order to practice!

Henry used the Tower far less as a residence than his father had done. The presence of so many

opponents to his regime and victims of his whims can hardly have been an inducement. The architecture of his new palace at Bridewell, as well as that of Whitehall and Hampton Court, was more appealing to this Renaissance king than the medieval apartments at the Tower. Nonetheless, a certain amount of work was done to the Tower in his reign. A fire in 1512 necessitated the complete rebuilding of the Chapel of St Peter ad Vincula, and it was re-sited. This is why the chapel is associated with the famous executions of the sixteenth to eighteenth centuries and none before.

In 1532 Thomas Cromwell, under orders from Henry, carried out a survey and refurbishment of the palace buildings at the Tower. This work was completed in time for Henry and Anne Boleyn to stay there in 1533 prior to her coronation, when one of the first recorded gun salutes took place on Tower Wharf. This ceremonial use of the Tower, already seen as an historic symbol which could grant the monarch much needed credibility, was perhaps a calculated exercise to give Henry's new queen as much legitimacy as possible.

The Mint's work increased due to the debase-

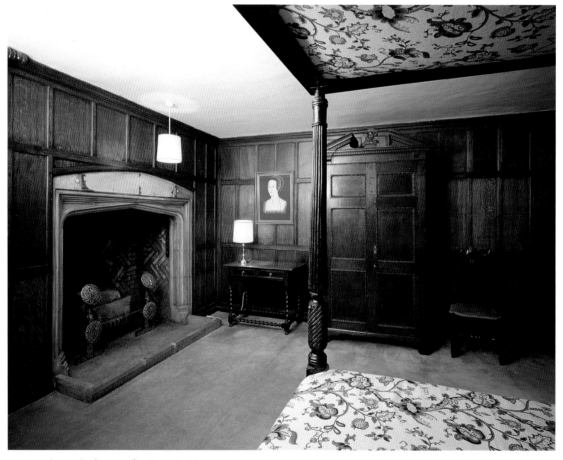

Anne Boleyn's bedroom, the Queen's House

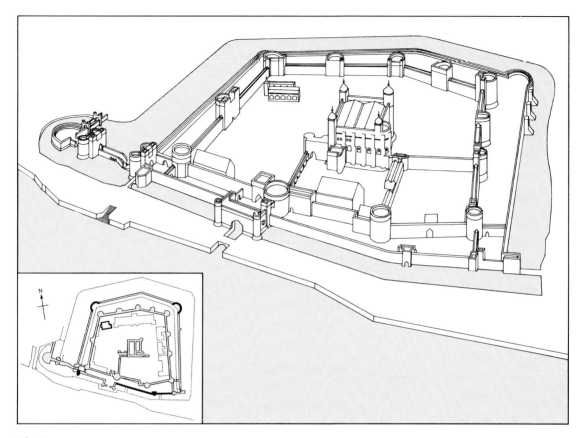

The Tower c. 1547

ment of the coinage towards the end of Henry's reign, brought on by financial difficulties. The costly war with France also probably necessitated building new storehouses for the Ordnance department in 1545–7. The roof of the White Tower was strengthened so it could bear cannons.

For the rest of the Tudor period the Tower continued to be the prison for many leading political figures and dissenters. Edward VI was persuaded to alter the succession, naming Lady Jane Grey, a fellow Protestant and granddaughter of Henry VIII's youngest sister, his heir. Merely sixteen, she was taken to the Tower and pro-

claimed Queen. However, her reign lasted only nine days; the rightful heir, Edward's half sister, Mary, daughter of Catherine of Aragon, establishing herself with popular support and Lady Jane Grey experienced a swift demotion – from the palace apartments, via the Lieutenant's Lodgings, to the Gentleman Gaoler's house on Tower Green. Her new husband, Guildford Dudley, was imprisoned with his four brothers in the Beauchamp Tower, and their father, John Dudley, Duke of Northumberland, architect of the whole coup attempt, was placed in the Bloody Tower before his execution in August 1553.

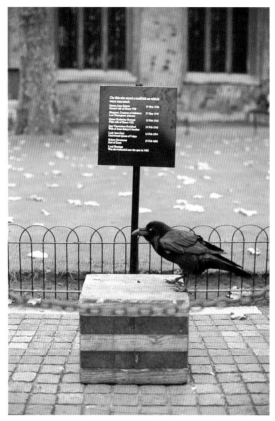

A raven at the scaffold site

Mary had moved to the Tower for safety during Wyatt's rebellion and at one time the Tower itself was under threat from the rebels positioned on the opposite bank of the river. At the Tower several pieces of ordnance were aimed at Southwark, but it was to be the last time there would be military confrontation at the Tower.

As well as filling the Tower with more prisoners than ever before, Mary made use of it in more stately ways. While her brother Edward was being given a Protestant funeral service at Westminster she held a requiem mass for him in St John's Chapel. It was here, too, that she is said to have been married by proxy to Philip of Spain, a move which was unpopular. It did, however, benefit the Tower in that the Mint won its first foreign contract with an order to mint coins for Spain.

Elizabeth, welcomed to the throne in 1558 with great popular acclaim, spent time at the Tower before her coronation, but never stayed there again; a combination, no doubt, of its bad associations for her and it being old-fashioned. Its use as a state prison was now paramount, but imprisonment in the Tower was not necessarily one of hardship. The system of allowances, depending on rank, continued, as did the custom of prisoners improving their standard of living from their own purse. Some had one or more servants and even their families with them. Although some were allowed the liberty of the Tower, i.e. to go anywhere but remain within its walls, the numerous inscriptions bear testimony to the long hours of tedium. Evidence of another diversion was noted by Pepys – a piece of iron in one of the wall walks with 'holes to put in a peg for every turn that they made upon that walk'.

An excellent description of imprisonment in the Tower is given in the autobiography of John Gerard, a Jesuit confined in the Salt Tower in 1597. The warder brought him straw to sleep on

Jane, her husband and two of his brothers, were condemned for treason, but no date was set for the execution. It may have been that Mary intended to be lenient, but the rebellion of Sir Thomas Wyatt in early 1554 confirmed that the crown was still under threat. For a time it seemed that Princess Elizabeth was implicated, and she was interned in the Bell Tower for two months, allowed only to walk the ramparts (still known in that section as Princess Elizabeth's walk). Wyatt was to exonerate Elizabeth on the scaffold but the sentence on Lady Jane Grey and her husband was now carried out – six days after the collapse of the rebellion.

as 'the prisoner must find his own bed and other furniture he wants'. Gerard was tortured in the basement of the White Tower, where he was three times hung from manacles from one of the pillars; of the second occasion he wrote: 'the gauntlets were placed on the same part of my arms as last time. They would not fit anywhere else, because the flesh on either side had swollen into small mounds, leaving a furrow between; and the gauntlets could only be fastened in the furrow. I felt a very sharp pain when they were put on.' His sense of touch did not return till five months later. In his case the torture yielded no results, and with another prisoner he escaped with the unwitting assistance of a warder.

Contrary to popular belief, torture was not frequently used, but was of such severity that a royal warrant was required, although there were probably occasions when it was illegally employed. Elizabeth's reign seems to have been the worst – fifty-three warrants were issued, and the rack the most popular instrument. As well as the manacles used on Gerard, a third device, the invention of a Lieutenant of the Tower in Henry

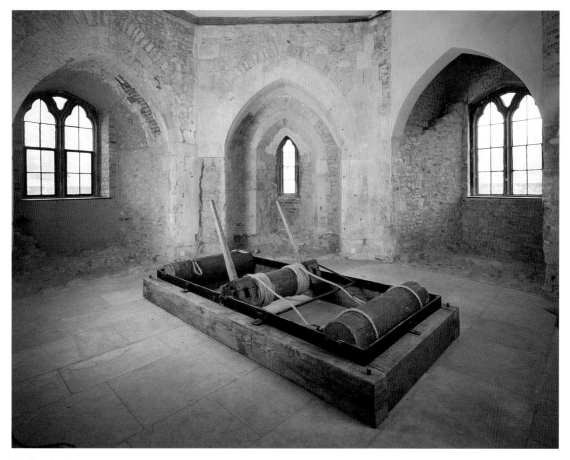

Rack, Martin Tower

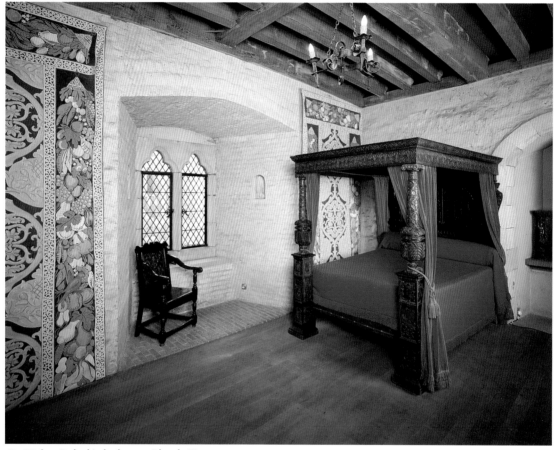

Sir Walter Ralegh's bedroom, Bloody Tower

VIII's reign, was the so-called Scavenger's Daughter, which compressed the body into a ball.

Elizabeth's successor, James I (1603–25), held court at the Tower for a short period after his accession, and subsequently went there to see animal fights. It was perhaps under his influence that the menagerie was better organized, with a series of cages built in the Lion Tower in 1603–5. Later in the reign a gallery was constructed for spectators. Sir Walter Ralegh was imprisoned in the Tower for much of James's reign, although this was not his first visit (see p. 24). This time he was in the Bloody Tower, condemned for taking part in the Main Plot – an attempt to replace James by his cousin Arabella Stuart. She too came to the Tower, where she died in 1615. On the scaffold in 1618, after thirteen years imprisonment, Ralegh railed against 'that Tower, where I have suffered so much adversity and a long sickness'. Yet he seems to have kept himself well occupied and at times was joined by his wife and two sons. He grew tobacco and other exotic plants

in the Tower garden and converted the henhouse into a chemical laboratory. He was visited by friends, and even some American Indians, whom he had brought back from Guiana in 1595, came in for lessons in English, law and religion. It was also during his confinement that he wrote his influential *History of the World*.

Ralegh must have had some consolation from contact with his fellow prisoner, the 'Wizard Earl', the ninth Earl of Northumberland. He, too, conducted scientific experiments, and employed mathematicians and alchemists. He managed his estates from his quarters in the Martin Tower, and even leased the Brick Tower for his son's household. He had been imprisoned (and was ultimately released) in connection with the Gunpowder Plot. Those at the centre of the Catholic plot to blow up the King and Parliament were less fortunate. Guy Fawkes was put on the rack and interrogated in the Council Chamber in the Queen's House before his death.

Charles I was the first king never to visit the Tower during his reign. Even the traditional procession to Westminster for the coronation was

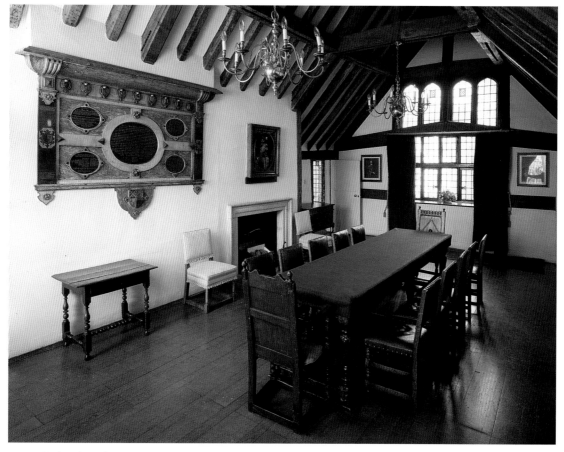

Council Chamber, the Queen's House

cancelled because of an outbreak of the plague. The Tower had now ceased to be a royal residence, while still fulfilling its other original function, as a military fortress. It continued to be well used as a prison during and after the Civil War and again after the changes of regime in 1660 and 1688, but thereafter this use was to become increasingly sporadic. Meantime the ancillary uses of the Tower continued, or began to expand, particularly after 1660 – the armoury, the Mint, the record office, the menagerie, the Crown Jewels store.

The last king to proceed to his coronation from the Tower was Charles II, the procession being abandoned by his successors as too expensive. For Charles it was a calculated act, taking place on St George's Day, to associate him with a continuing tradition. The ceremony had to wait a year for new regalia to be made; the old set had been dispersed and destroyed after Charles I's execution. It was during Charles II's reign that the regalia was put on public display for the first time.

A more calculated public display was the Line of Kings, each mounted in armour upon a model horse, intended to show the distinguished ancestry of the new king. For this reason Edward II and Richard III were absent! Historical accuracy was also overlooked; they were all dressed in armour dating from the sixteenth century and William the Conqueror was even displayed with a musket. The Spanish Armoury was set up in 1688 to show trophies from the defeat of the Spanish Armada, a hundred years before, although some of the pieces dated from Henry VIII's reign!

Samuel Pepys was briefly imprisoned in the Tower in 1679, as part of the Popish Plot. Also imprisoned in this reign was William Penn, for writing a tract against the doctrine of the Trinity. He echoed the thoughts of many prisoners when he said: 'The Tower is to me the worst argument

Wall of the inner ward with New Armouries beyond

in the world. My prison will be my grave before I will budge a jot.' He was released after seven months, obviously forgiven because Charles granted him a charter for Pennsylvania in the American colonies, naming it Penn in honour of Penn's father, an admiral.

After the Restoration (1660) the Office of Ordnance expanded to include responsibility for fortifications nationwide, which brought increased demand for space at the Tower. In 1664 a new storehouse was built, now known as the New Armouries, and another storehouse was built in the Coldharbour area, to the south of the Cold-

harbour Gate. Further expansion of the Ordnance department in the reigns of James II and William and Mary resulted in the demolition of large parts of the old palace apartments south of the White Tower, as well as construction of the Grand Store-house in 1688–92, on the sight of the present Waterloo Block.

The Ordnance also had responsibility for the 'astronomical observator' or first Astronomer Royal, John Flamsteed, appointed in 1675, whose observatory was in the White Tower. The Ordnance department built a new observatory at Greenwich later that year, to designs by Sir Christopher Wren (himself Professor of Astronomy at Oxford till 1673). Lead retrieved during the demolition of Coldharbour Gate was melted down and used on the new observatory.

James II was the last Catholic king and he did not last long, the 'Bloody Assizes' under Judge Jeffreys hardly contributing to his popularity, and the Protestants William III (1689–1702) and Mary II (1689–94) were invited to take the throne. Jeffreys went to the Tower, but died before he could go to the block.

The Eighteenth and Nineteenth Centuries

The conflicts engendered by the attempts of James's son and grandson to take the throne in 1715 and in 1745 resulted in a fresh crop of prisoners. One, Lord Nithsdale, escaped on the eve of his execution in 1716, from the Queen's House, dressed as one of his wife's maids while his wife allayed suspicion by maintaining a mock conversation between herself and her now absent husband.

The peers executed in 1746 for complicity in the second Jacobite rebellion, the Earl of Kilmarnock, Lord Balmerino and Lord Lovat, were the last people to be beheaded on Tower Hill. The crowds turned out in such numbers to see the end of the 80-year-old Lord Lovat that a stand collapsed killing five spectators. In all some 112 had died on the spot over more than 350 years. The ending of the custom deprived the Tower staff of one of their perks: when Kilmarnock and Balmerino left their cells to go to their execution, the Deputy Lieutenant 'had the doors locked after them and the keys given to me, that if any valuable thing was left in them I might secure it as my perquisite' but as the goods were of 'little worth and no plate or things of dignity, I gave them all to the warders'.

The multiple functions of the Tower continued throughout the eighteenth century. However, in 1798 a Privy Council Committee recommended a new mint be erected outside the Tower to take advantage of steam-powered machines. The new building was in the Minories on Little Tower Hill and the keys to the Mint area in the Tower handed to the Constable in August 1812. With the ending of the Napoleonic Wars three years later, the arms factory which had been set up on Tower Wharf could be closed down and the work transferred to Lewisham and Enfield. This was to be the beginning of the winding down or termination of traditional Tower functions which went on throughout the nineteenth century, part of the Tower's transition from adjunct of state to historic monument. A key figure in the initial stages was the Duke of Wellington, Constable of the Tower 1826–52.

A distinguished military commander, Wellington was always conscious that the Tower was a fortress, and was rather wary of the increasing number of tourists. The menagerie was a particular cause for concern, since the expansion instigated by the new keeper, Alfred Cops, from 1822 meant that it was now blocking the entrance to the Tower. William IV gave Wellington permission to move the menagerie and in 1834 the

animals were taken out of the Tower, some perhaps joining the collection of the Zoological Society in Regents Park, which was the nucleus of the London Zoo.

The tourists came in such numbers that in 1841 the first official guide book was issued, and a new Jewel House was under construction when in October the Jewels themselves came under threat from fire. It started about 10.30 pm, probably in a flue in the Bowyer Tower and for a time it seemed it could be contained there. The resident battalion of Scots Fusiliers was mustered and 'the whole of the troops, several hundred in number, were seen rushing out of their quarters in all directions, many in a state almost of nudity'. They quickly turned their hand to rescuing arms and armour from the Grand Storehouse, to which the

fire had spread, and helped man the fire engines. Crowds gathered on Tower Hill to watch the spectacle of the great seventeenth-century building being destroyed. The intense heat melted the lead waterpipes on the White Tower. Gunpowder stored in the White Tower was hastily removed and dumped in the moat. It then became apparent that the Crown Jewels in the Martin Tower were in danger. The Lord Chamberlain had the keys and was unavailable, so the Master of the Jewel House, assisted by police and warders, had to break into the cage with a crowbar. The jewels were then temporarily stored in vaults in the Queen's House. Subsequent Jewel Houses proved inadequate and in 1869 the Wakefield Tower was adapted to house them.

The 1841 fire hastened the departure of the

Old Hospital Block, built in the eighteenth century

Ordnance Survey for Southampton, and in 1855 the Board of Ordnance itself was abolished and its functions transferred to the War Office. The Tower was thereafter just a garrison and store. The troops were provided with new quarters in the Wellington Barracks (now Block) on the site of the Grand Storehouse, with an adjacent Officers' Mess (now HQ of the Regiment of Fusiliers and their museum). Other building in the 1840s included a bastion in the outer north wall between Legge's Mount and Brass Mount, as protection against the Chartist rioters of 1848. In 1843 Wellington achieved another, long planned, improvement: the draining of the moat, filling the ditch to the former water level and laying sewage pipes. An outbreak of cholera had made it imperative and the cost, £400, bearable. Wellington is also well remembered for his reformation of the warder system (see p. 60).

The public records had been expanding and now occupied much of the White Tower, including the chapel, as well as the Wakefield Tower, which was even known as the Records Tower. Wellington argued that it would be safer (since gunpowder was kept in the White Tower) and more convenient if all the documents could be put together in one building, and eventually a purpose-built Public Records Office was built 1851–66 in Chancery Lane. This meant the Chapel of St John could be restored, and not long thereafter St Peter ad Vincula was also overhauled (see p. 27).

The final piece of work carried out by the Victorians was the restoration of the wall between the Wakefield and Salt Towers, Anthony Salvin's work. The Coldharbour storehouse was dismantled, as was the Lion Barbican and a building on the east side of the Tower was taken down in 1879 to reveal the remains of the Wardrobe Tower.

The Twentieth Century

World War I brought the Tower back into use as a prison for the first time since the Cato Street Conspiracy of 1820. Sir Roger Casement, the Irish nationalist, was held here prior to his death by hanging in Pentonville Gaol in 1916. The Tower itself was the scene of the execution of eleven spies, shot in the miniature rifle range in the northeast casemates. This was to be used once again in World War II when a German spy became the last person to be executed in the Tower. And the last prisoner of state was Rudolf Hess, Deputy Führer of the Third Reich. Writing to his wife later about his four-day stay in May 1941, he commented on how charming the Queen's House was, and how 'looking out of the window, I could see the English guardsmen doing their daily drill with endless endurance and a precision that would have done credit to Prussians, accompanied by resounding music. I could have managed very well, however, without the bagpipes.'

Remarkably, considering its proximity to the docks, the Tower survived the Blitz virtually unscathed. The 1848 bastion was destroyed and not rebuilt. Nor was the Main Guard, running from Wakefield Tower to the White Tower, a Victorian building whose loss revealed the remains of Henry III's wall to the inner ward.

In 1967 the Crown Jewels were removed to a new Jewel House in the base of the Waterloo Block, and the Wakefield Tower was restored in consequence. Housing the Crown Jewels is really the last of the Tower's historic functions to remain – the records, the Mint, the Ordnance, the prisoners, the royal inhabitants have all gone. Today the Tower is not just another stop on the tourist itinerary. Guarding the visible manifestations of majesty gives it a living core and a real function.

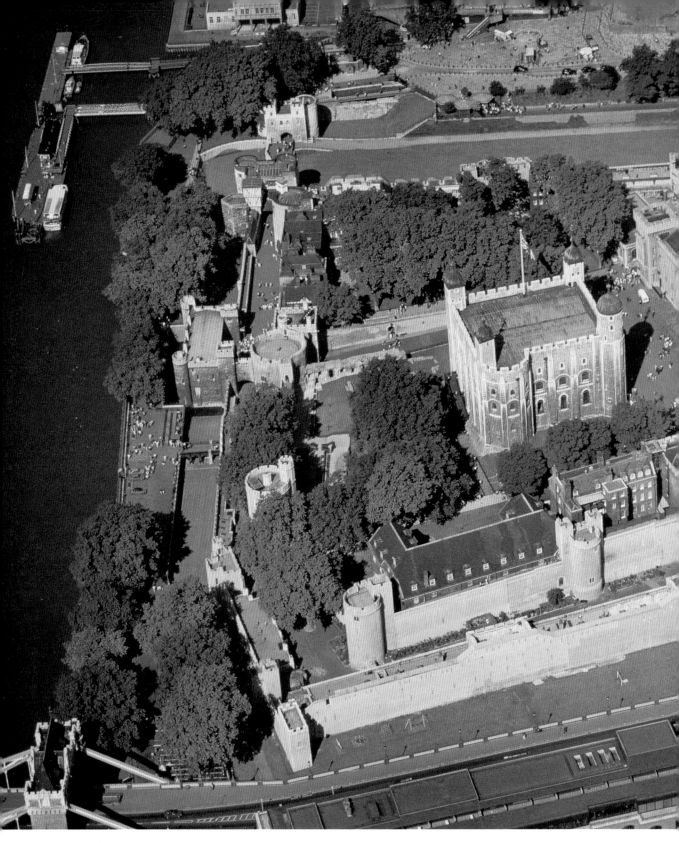

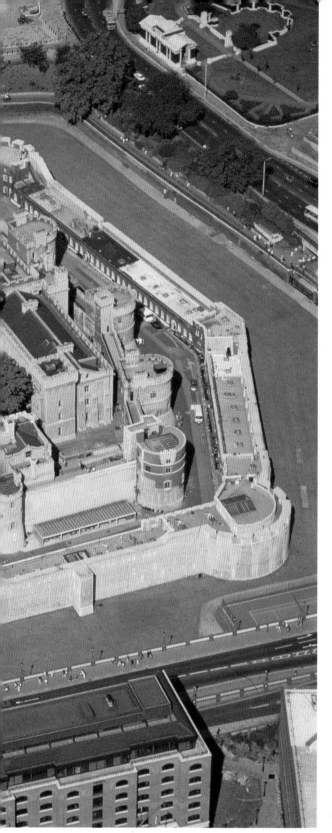

The Tower Today

The Tower of London is the most visited heritage site in Britain. In 1989 2.3 million people paid to enter the Tower. In addition, school groups accounted for another half a million, non-paying, visitors. Over seventy-five per cent of the people were foreign tourists and seventy per cent of all visitors were women.

The Tower also welcomes special-interest groups. Many Catholic groups come to pay homage to Saint Thomas More. By prior arrangement they are taken to the Lower Bell Tower, where More was imprisoned, and then visit the crypt of St Peter ad Vincula to see where the saint is buried. The first Sunday in November (when the Tower is closed to the general public), the Tower is opened for the disabled, who come to the Tower in organized groups. Private tours are also given on certain days by Yeoman Warders to members of the Police Federation, with whom they are affiliated.

A trip to the Tower is also a favourite item on the itinerary of foreign dignitaries, particularly the wives of presidents and prime ministers, who come while their husbands are attending meetings at Downing Street and elsewhere. The ladies are given a private viewing of the Crown Jewels before the Tower opens, and are shown historic rooms in the Queen's House not seen by the general public.

The Tower of London from the air (Crown Copyright)

Acknowledgements

I am indebted to the large number of people who have helped me with this book. There are too many to mention them all by name, but I am particularly grateful to the following:

The Governor of the Tower, Major-General Tyler, and the following members of his staff: Colonel Anderson, Colonel McKinley, Tony Cornwell, Peter Hammond, Kathryn Derbyshire and Tracy Dalby, who have been generous with their time in interviews, consultations and administrative support. Geoffrey Parnell at English Heritage, and Robert Melling, Curator of the Crown Jewels, were both invaluable further sources of information.

The body of Yeoman Warders have been enthusiastic about this project from the beginning, and I am especially thankful to Chief Yeoman Warder Dennis Harding, Yeoman Gaoler John Maher, Yeoman Raven Master John Wilmington, Yeoman Clerk Norman Jackson, Chapel Yeoman Clerk Peter Birch, and Yeoman Warders Crawford Butler, Brian Canderton, Joe David, Peter Hudson, Richard Sands, Tom Trent and Rod Truelove. Brian Harrison very kindly read the whole manuscript and contributed his own extensive knowledge of the Tower.

Mrs Fay Pottinger gave me permission to reproduce her late husband's map of the Tower.

I enjoyed the partnership with Julia MacKenzie, my co-author and editor, and appreciate the enormous amount of work she did, as well as the help given me by my assistant Bharath Ramamrutham, some of whose photographs appear in the book. My wife and partner, Linda, edited the pictures and supported the whole project.

My final thanks go to Stephen Spencer, Merchandising Manager at the Tower, whose initial interest in my photographs made the whole project possible.